RUSTIC MODERN
Knits

23
Sophisticated
Designs

YUMIKO ALEXANDER

INTERWEAVE.
interweave.com

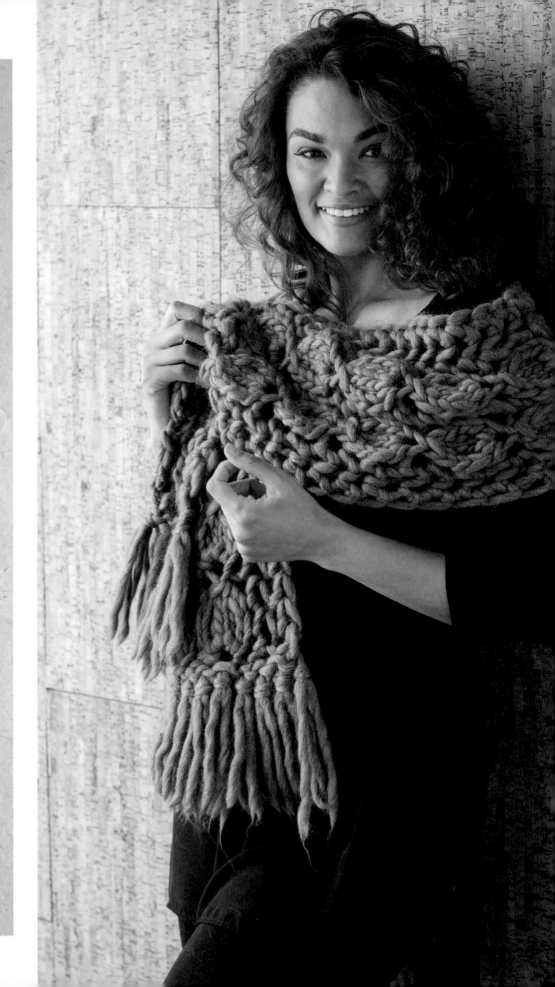

EDITOR
Erica Smith

TECHNICAL EDITOR
Minh-Huyen Nguyen

PHOTOGRAPHER
Joe Hancock

HAIR + MAKEUP
Kathy MacKay

STYLIST
Allie Liebgott

ART DIRECTOR
Charlene Tiedemann

COVER + INTERIOR DESIGN
Pamela Norman

PRODUCTION
Katherine Jackson

 Interweave
A division of F+W Media, Inc.
4868 Innovation Dr.
Fort Collins, CO 80525
interweave.com

Manufactured in U.S.A.
by RR Donnelley Roanoke

Library of Congress
Cataloging-in-Publication Data

Alexander, Yumiko.
Rustic modern knits : 23 sophisticated
designs / Yumiko Alexander.
pages cm
Includes index.
ISBN 978-1-62033-630-4 (pbk.)
ISBN 978-1-62033-631-1 (PDF)
1. Knitting--Patterns. I. Title.
TT825.A468 2014
746.43'2--dc23
2014021406

10 9 8 7 6 5 4 3 2 1

Contents

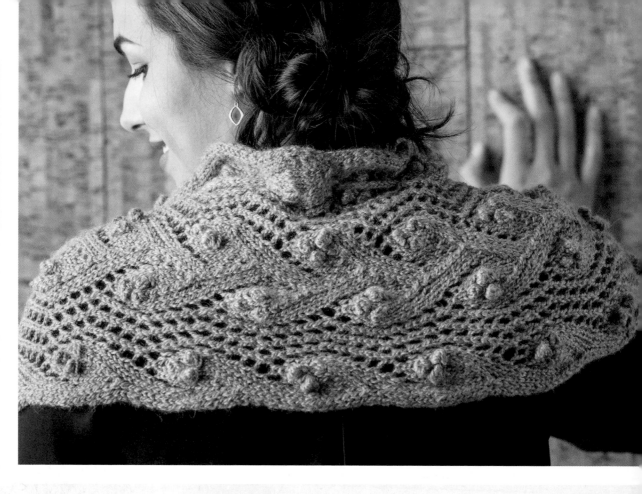

Introduction

When my first book with Interweave, *Rustic Modern Crochet*, was published, I was delighted to read book reviews stating that the designs were simple, created with eye-catching construction, and both a pleasure to work with and wear. I love working with simpler shapes, so I can enjoy knitting and crocheting while creating unique finished garments. This is the reason we make handmade items!

I was born in Japan and lived there until my late twenties, when I got married and moved to America. I started knitting at the age of eleven, learning from a knitting book, because I loved working with my hands. I started designing in high school, and I had the chance to meet a knitting designer who taught me how to design. I started to sell my original finished knitted garments at exhibitions and at a store in Japan.

I have really enjoyed my time in the United States. Now that I have started sharing my knitting and crochet designs, this country feels like a second home to me. Although my English is not perfect, I have always felt like I can communicate and express myself through my design work. I have met many wonderful friends through knitting and crochet.

When Interweave told me they were interested in publishing a knitting book to follow *Rustic Modern Crochet*, I was ecstatic. I wanted to focus on accessories that are unique and different. I have tried to produce knitted designs that resemble crochet (Allium, Hydrangea), take the shape of huge squares using the entrelac technique (English Garden), bloom into dimensional motifs (Pansies), and evolve as layered knitted fabric (Allium). As with some of my previous designs, I have tried to keep the silhouettes simple without shaping (Acorns and Ivy, Allium, Bricks, English Garden, Hyacinth, Japanese Lanterns, Lace Lichen, Lattice, Lily of the Valley, Midnight Tendril, Winter Rose). At times the pieces are nonsymmetrical (Baby's Breath, Clematis, Hyacinth) or asymmetrical (Field of Wheat, Waves of Grain).

My design ideas come from what I want to have in my closet, and each design needs to be something I can't find in the usual clothing stores. I want to create designs I can be proud to wear and use, both functional and fashionable. I hope the same holds true for you as you create these garments!

—Yumiko Alexander

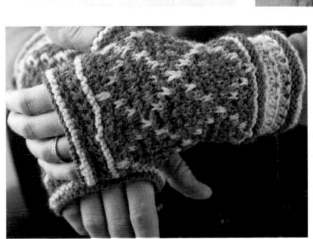

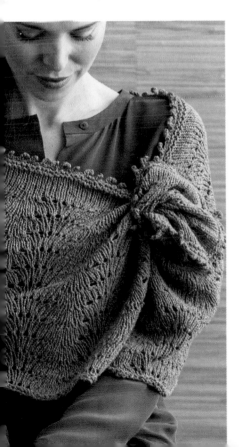

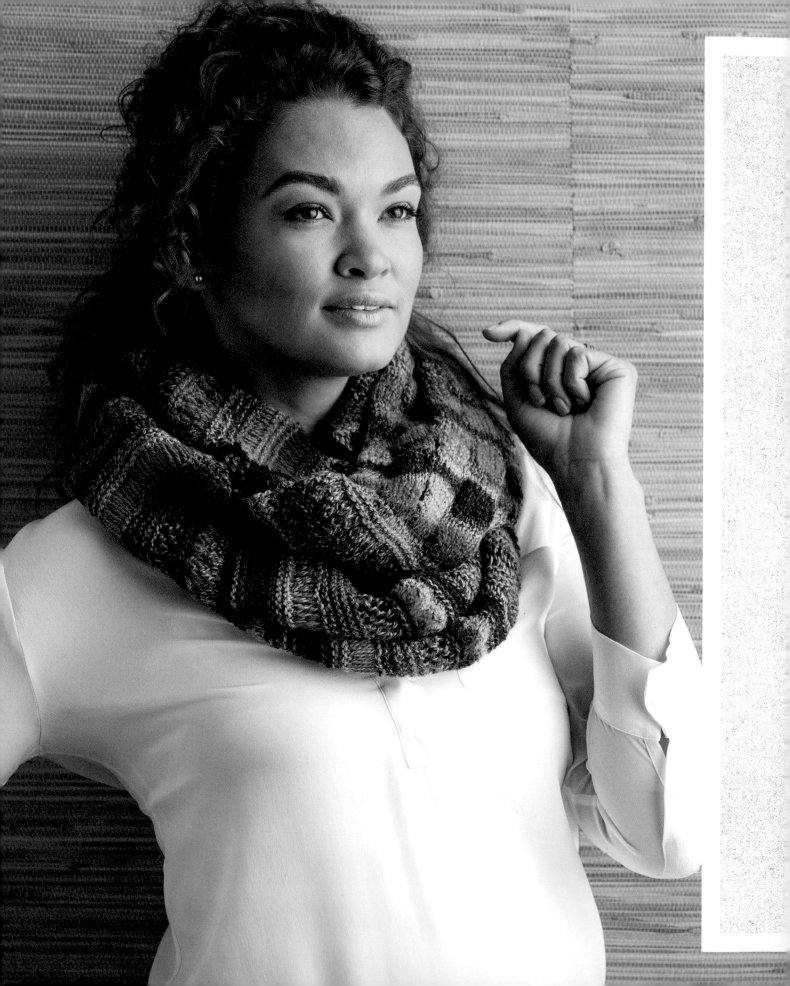

FINISHED SIZE
About 14½" (37 cm)
wide and 61½" (156 cm)
circumference.

YARN
DK weight (#3 Light).

Shown here: Schop-
pel Wolle Zauberball
Starke 6 (75% super-
wash wool, 25% nylon;
437 yd [400 m]/150 g):
#1701, 2 balls.

NEEDLES
Size U.S. 6 (4 mm).

*Adjust needle size if
necessary to obtain the
correct gauge.*

NOTIONS
Smooth waste yarn for
provisional cast-on;
tapestry needle.

GAUGE
20 sts and 36 rows of
main patt = 4" (10 cm)
wide and 5½" (14 cm)
long after blocking.

20 sts and 20 rows = 4"
(10 cm) in pop-up patt
after blocking.

Bricks

I was designing a sweater with self-striping yarn several years ago and became interested in how the color flows differently depending on the stitch pattern. This cowl is worked in two textured stitch patterns, and the textures show much more clearly than when using a solid color yarn. The pop-up stitch pattern is especially interesting to work with self-striping yarn because one color stays on top to make each pop-up. Pop-ups are created by working short sections with extra rows.

STITCH GUIDE

SL 2TOG PWISE TBL

With yarn in front, slip 2 sts together as if to p2tog tbl.

POP-UP PATTERN

(multiple of 14 sts + 2)

ROW 1: (RS) K1, *[k7, turn, p7, turn] 4 times, k14; rep from * to last st, k1.

ALL EVEN-NUMBERED ROWS: K1, purl to last st, k1.

ROW 3: Knit.

ROW 5: K8, *[k7, turn, p7, turn] 4 times, k14; rep from * ending last rep with k8 instead of k14.

ROW 7: Knit.

ROW 8: Rep Row 2.

Rep Rows 1–8 for patt.

MAIN PATTERN

(multiple of 4 sts + 2)

ROWS 1–4: Knit.

ROW 5: *K1, work (k1, yo, k1) all in the same st, turn, p3, turn, k3; rep from * to last 2 sts, k2.

ROW 6: K1, *p1, sl 2tog pwise tbl (see Stitch Guide), p1, pass 2 slipped sts over st just worked (p2sso); rep from * to last st, k1.

ROW 7: K1, *k1, work (k1, yo, k1) all in the same st, turn, p3, turn, k3; rep from * to last st, k1.

ROW 8: K1, *sl 2tog pwise tbl, p1, p2sso, p1; rep from * to last st, k1.

ROWS 9–16: Knit.

ROW 17: *Insert needle into next st and wrap yarn twice around needle, then knit the st withdrawing all the wraps along with the needle; rep from * to end.

ROW 18: *Knit working only into the first loop and dropping the 2nd loop to create an elongated stitch; rep from * to end.

ROWS 19–22: Knit.

ROW 23: *Insert needle into next st and wrap yarn 3 times around needle, then knit the st withdrawing all the wraps along with the needle; rep from * to end.

ROW 24: *Knit working only into the first loop and dropping the 2nd and 3rd loops to create an elongated stitch; rep from * to end.

ROWS 25–32: Knit.

ROWS 33–36: K1, *yo, ssk; rep from * to last st, k1.

Rep Rows 1–36 for patt.

Instructions

With smooth waste yarn and using a provisional method (see Glossary), CO 86 sts.

SET-UP ROW: (WS) Purl.

ROWS 1–80: Work Rows 1–8 of Pop-up patt (see Stitch Guide) a total of 10 times.

ROWS 81–332: Work Rows 1–36 of Main patt (see Stitch Guide) a total of 8 times.

ROWS 333–345: Work Rows 1–13 of Main patt once more.

ROW 346: (WS) Knit.

Finishing

Carefully remove waste yarn from provisional CO and place 86 exposed sts on empty needle. Cut yarn, leaving a tail about 43½" (110.5 cm) long. Thread tail on a tapestry needle and use the Kitchener st (see Glossary) to graft the live sts tog with exposed sts from provisional CO. Weave in loose ends. Block if desired.

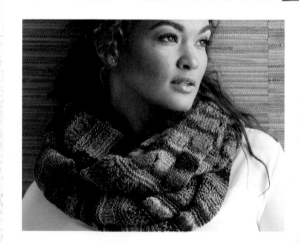

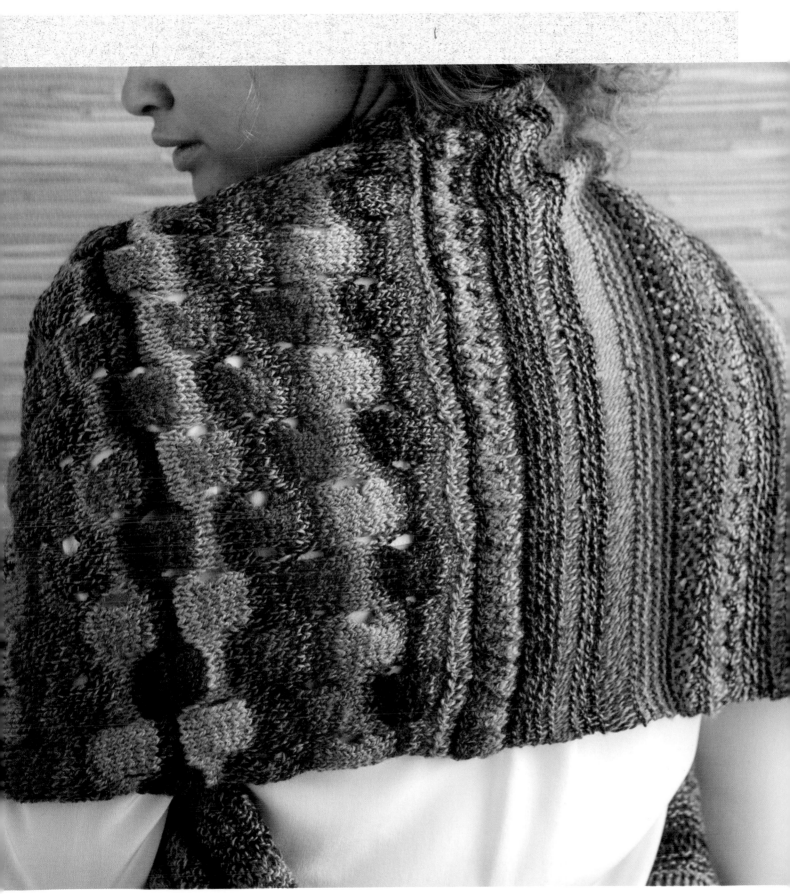

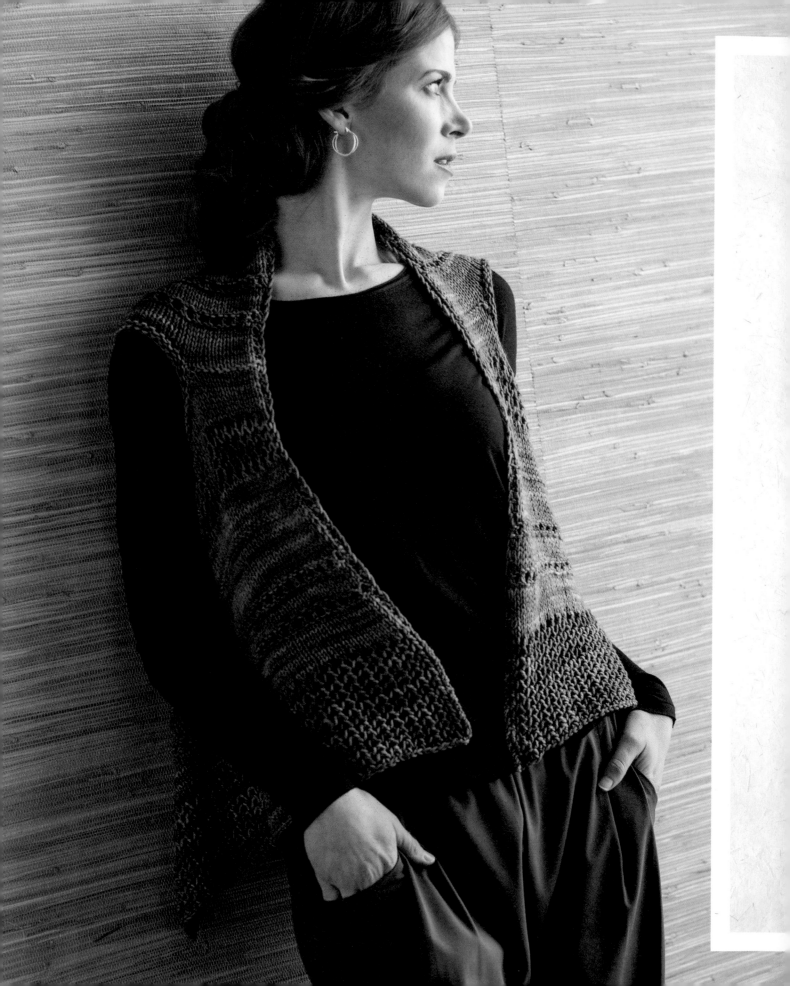

FINISHED SIZE

About 42¾ (52½, 58)"
(108.5 [133.5, 147.5] cm)
wide and 18¾ (20¾, 21¾)"
(47.5 [52.5, 55] cm) long.

Vest shown measures
42¾" (108.5 cm).

YARN

Sportweight (#2 Fine).

Shown here: Malabrigo
Arroyo (100% superwash
merino wool; 335 yd
[306 m]/100 g): #43
Plomo, 2 (3, 4) skeins.

NEEDLES

Size U.S. 10½ (6.5 mm):
straight and 16"
(40.5 cm) circular (cir).

*Adjust needle size if
necessary to obtain the
correct gauge.*

NOTIONS

Smooth waste yarn for
provisional cast-on;
markers (m); tapestry
needle.

GAUGE

16¼ sts and 24 rows
= 4" (10 cm) in St st after
blocking.

16¼ sts and 24½ rows
= 4" (10 cm) in textured
stripe patt.

16¼ sts and 24 rows
= 4" (10 cm) in lace
border patt.

This vest is a simple rectangular shape with armholes worked in a combination of stockinette stitch, garter stitch, and a one-row repeat lace pattern. This project is deliberately worked at a looser gauge than is typical for sportweight yarn to create a drapey effect and would be good for spring and fall. Using worsted-weight yarn at the same gauge would make a winter vest.

STITCH GUIDE

SL 1 PWISE WYF
Slip 1 st purlwise with yarn in front.

STOCKINETTE STITCH WITH SELVEDGE
(St st with selvedge)

ROW 1: (RS) Sl 1 pwise wyf, knit to end.

ROW 2: (WS) Sl 1 pwise wyf, k1, purl to last 2 sts, k2.

TEXTURED STRIPE PATTERN
(multiple of 2 sts + 2)

ROW 1: (WS) Sl 1 pwise wyf, knit to end.

ROW 2: (RS) Sl 1 pwise wyf, *yo, ssk; rep from * to last st, k1.

ROW 3: Sl 1 pwise wyf, knit to end.

ROW 4: Sl 1 pwise wyf, knit to end.

ROW 5: Sl 1 pwise wyf, k1, purl to last 2 sts, k2.

ROWS 6–8: Rep Rows 4 and 5 once, then rep Row 4 once more.

ROWS 9–11: Rep Rows 1–3.

Rep Rows 1–11 for patt.

LACE PATTERN WITH SELVEDGE
(multiple of 2 sts)

ROW 1: Sl 1 pwise wyf, *yo, ssk; rep from * to last st, k1.

Rep Row 1 for patt.

LACE BORDER
(multiple of 2 sts)

Row 1: K1, *yo, ssk; rep from * to last st, k1.

Rep Row 1 for patt.

NOTE

This vest is worked sideways, so the row gauge will determine the circumference of the garment while the stitch gauge will determine the length. If you obtain the correct stitch gauge but your row gauge is too small or too large, you can work more/ fewer rows of St st on either side of the textured stripe patt or lace patt.

Instructions

NOTE: The vest is worked by provisionally casting on stitches and then knitting the left front, back, and right front followed by the right lace band. The provisional CO stitches are then used to knit the left lace band.

Using waste yarn and a provisional cast-on method (see Glossary), CO 76 (84, 88) sts— this counts as Row 1 (RS).

LEFT FRONT
Starting with a WS row, work in St st with selvedge (see Stitch Guide) for 10 (14, 16) rows.

Work Rows 1–11 of Textured Stripe patt (see Stitch Guide) 1 (1, 1) time.

Starting with a RS row, work in St st with selvedge for 9 (13, 15) rows.

NEXT ROW: (WS—garter ridge) Sl 1 pwise wyf, knit to end.

Starting with a RS row, work in St st with selvedge for 10 (14, 16) rows.

Work Row 1 of Lace patt with selvedge (see Stitch Guide) 8 (8, 8) times.

Starting with a RS row, work in St st with selvedge for 7 (9, 9) rows.

SET-UP ROW: (WS) Sl 1 wyf, k1, p11 (16, 17), BO 28 (30, 32) sts pwise, p33 (34, 35), k2.

LEFT ARMHOLE
Size 42¾" (108.5 cm) only

ROW 1: (RS) Sl 1 pwise wyf, knit to last 2 sts before BO, k2tog, turn—34 sts before BO.

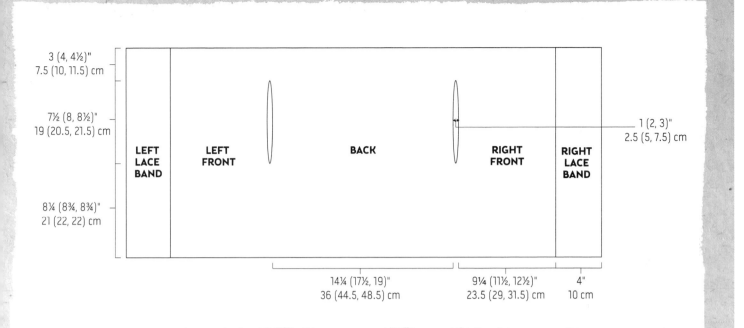

3 (4, 4½)"
7.5 (10, 11.5) cm

7½ (8, 8½)"
19 (20.5, 21.5) cm

8¼ (8¾, 8¾)"
21 (22, 22) cm

LEFT LACE BAND

LEFT FRONT

BACK

RIGHT FRONT

RIGHT LACE BAND

1 (2, 3)"
2.5 (5, 7.5) cm

14¼ (17½, 19)"
36 (44.5, 48.5) cm

9¼ (11½, 12½)"
23.5 (29, 31.5) cm

4"
10 cm

ROW 2: Knit to end.

ROW 3: Sl 1 pwise wyf, knit to last st before BO, M1, k1—35 sts before BO.

Cut yarn leaving sts on needle. Rejoin yarn with RS facing to other BO edge.

ROW 1: (RS) Ssk, knit to end—12 sts after BO.

ROW 2: Sl 1 pwise wyf, knit to BO.

ROW 3: K1, M1, knit to end—13 sts after BO.

ROW 4: Sl 1 pwise wyf, k1, p11, using backward-loop method, CO 28 sts, p33, k2—76 sts total.

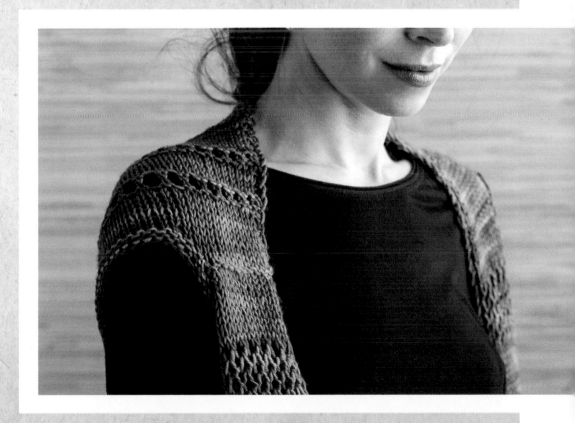

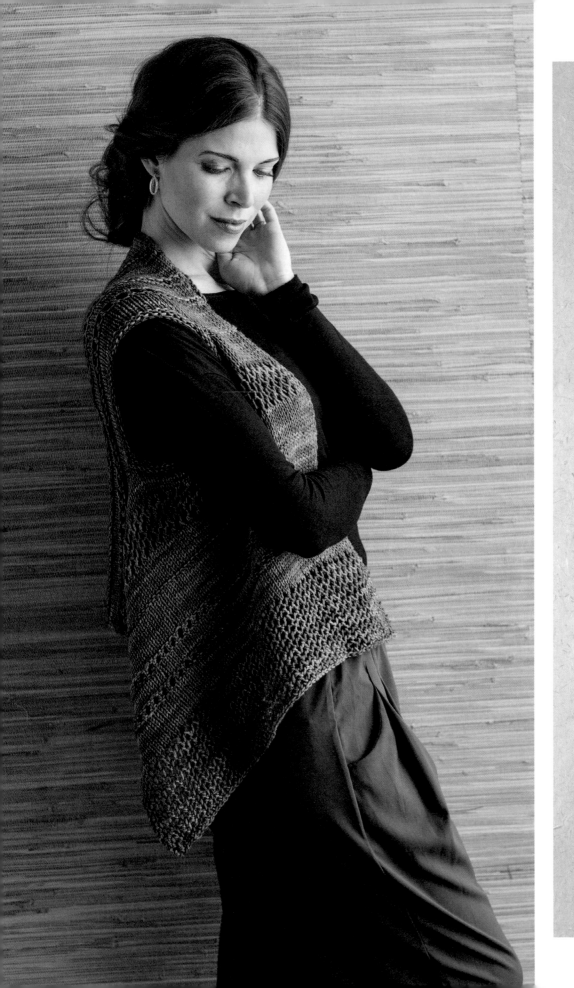

Size 52½" (133.5 cm) only

ROW 1: (RS) Sl 1 pwise wyf, knit to last 2 sts before BO, k2tog, turn—35 sts before BO.

ROW 2: P2tog, purl to end—34 sts before BO.

ROW 3: Sl 1 pwise wyf, knit to BO.

ROW 4: Knit to end.

ROW 5: Sl 1 pwise wyf, knit to BO.

ROW 6: P1, M1P (see Glossary), purl to end—35 sts before BO.

ROW 7: Sl 1 pwise wyf, knit to last st before BO, M1, k1—36 sts before BO.

Cut yarn leaving sts on needle. Rejoin yarn with RS facing to other BO edge.

ROW 1: (RS) Ssk, knit to end—17 sts after BO.

ROW 2: Sl 1 pwise wyf, k1, purl to last 2 sts before BO, p2tog tbl—16 sts after BO.

ROW 3: Knit to end.

ROW 4: Sl 1 pwise wyf, knit to BO.

ROW 5: Knit to end.

ROW 6: Sl 1 pwise wyf, k1, purl to last st before BO, M1P, p1—17 sts after BO.

ROW 7: K1, M1, knit to end—18 sts after BO.

ROW 8: Sl 1 pwise wyf, k1, p16, using backward-loop method, CO 30 sts, p34, k2—84 sts total.

Size 50" (147.5 cm) only

ROW 1: (RS) Sl 1 pwise wyf, knit to last 2 sts before BO, k2tog, turn—36 sts before BO.

ROW 2: Purl to end.

ROW 3: Sl 1 pwise wyf, knit to last 2 sts before BO, k2tog— 35 sts before BO.

ROW 4: P2tog, purl to end— 34 sts before BO.

ROW 5: Sl 1 pwise wyf, knit to BO.

ROW 6: Knit to end.

ROW 7: Sl 1 pwise wyf, knit to BO.

ROW 8: P1, M1P, purl to end— 35 sts before BO.

ROW 9: Sl 1 pwise wyf, knit to last st before BO, M1, k1— 36 sts before BO.

ROW 10: Purl to end.

ROW 11: Sl 1 pwise wyf, knit to last st before BO, M1, k1—37 sts before BO.

Cut yarn, leaving sts on needle. Rejoin yarn with RS facing to other BO edge.

ROW 1: (RS) Ssk, knit to end— 18 sts after BO.

ROW 2: Sl 1 pwise wyf, k1, purl to BO.

ROW 3: Ssk, knit to end—17 sts after BO.

ROW 4: Sl 1 pwise wyf, k1, purl to last 2 sts before BO, p2tog tbl— 16 sts after BO.

ROW 5: Knit to end.

ROW 6: Sl 1 pwise wyf, knit to BO.

ROW 7: Knit to end.

ROW 8: Sl 1 pwise wyf, k1, purl to last st before BO, M1P, p1—17 sts after BO.

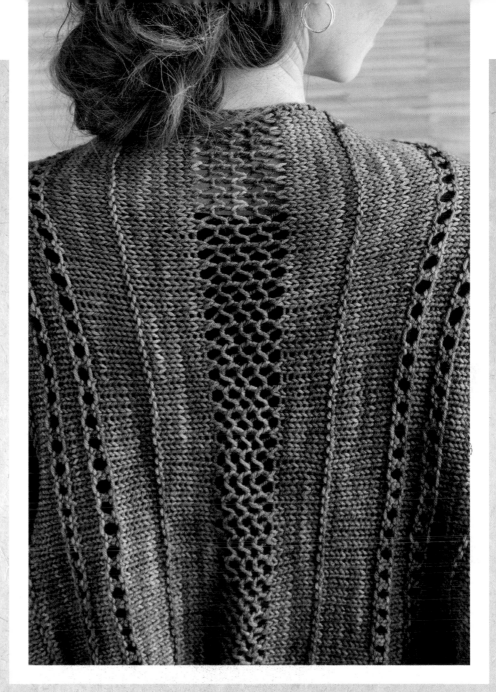

ROW 9: K1, M1, knit to end— 18 sts after BO.

ROW 10: Sl 1 pwise wyf, k1, purl to BO.

ROW 11: K1, M1, knit to end— 19 sts after BO.

ROW 12: Sl 1 pwise wyf, k1, p17, using backward-loop method, CO 32 sts, p35, k2—88 sts total.

BACK
Starting with a RS row, work in St st with selvedge for 9 (11, 11) rows.

Work Rows 1–11 of Textured Stripe patt 1 (1, 1) time.

Starting with a RS row, work in St st with selvedge for 9 (13, 15) rows.

NEXT ROW: (WS—garter ridge) Sl 1 pwise wyf, knit to end.

Starting with a RS row, work in St st with selvedge for 10 (14, 16) rows.

Work Row 1 of Lace patt with selvedge 8 (8, 8) times.

Starting with a RS row, work in St st with selvedge for 9 (13, 15) rows.

NEXT ROW: (WS—garter ridge) Sl 1 pwise wyf, knit to end.

Starting with a RS row, work in St st with selvedge for 11 (15, 17) rows.

Work Rows 1–11 of Textured Stripe patt 1 (1, 1) time.

Starting with a RS row, work in St st with selvedge for 7 (9, 9) rows.

SET-UP ROW: (WS) Sl 1 pwise wyf, k1, p11 (16, 17), BO 28 (30, 32) sts pwise, p33 (34, 35), k2.

RIGHT ARMHOLE

Rep Left Armhole section.

RIGHT FRONT

Starting with a RS row, work in St st with selvedge for 8 (10, 10) rows.

Work Row 1 of Lace patt with selvedge 8 (8, 8) times.

Starting with a RS row, work in St st with selvedge for 9 (13, 15) rows.

NEXT ROW: (WS—garter ridge) Sl 1 pwise wyf, knit to end.

Starting with a RS row, work in St st with selvedge for 11 (15, 17) rows.

Work Rows 1–11 of Textured Stripe patt 1 (1, 1) time.

Starting with a RS row, work in St st with selvedge for 10 (14, 16) rows.

RIGHT LACE BAND

Work Row 1 of Lace Border (see Stitch Guide) 24 (24, 24) times or until lace border measures 4" (10 cm). Loosely BO all sts.

LEFT LACE BAND

Carefully remove waste yarn from provisional CO and place 76 (84, 88) exposed sts on needle.

Work Row 1 of Lace Border 24 (24, 24) times or until lace band measures 4" (10 cm). Loosely BO all sts.

Finishing

Weave in loose ends. Block garment.

NOTE: The piece is knitted at a loose gauge, so steam blocking or spray blocking is recommended because fabric knitted at a loose gauge tends to completely lose shape after wet blocking.

ARMHOLE EDGES

With RS facing and cir needle, pick up and knit 28 (30, 32) sts from armhole BO edge working from bottom to top, then pick up and knit 3 (6, 8) sts from side edges over gap, then pick up and knit 28 (30, 32) sts from armhole CO edge working from top to bottom, then pick up and knit 3 (6, 8) sts from side edges over gap.

Place marker (pm) and join for working in rnds—62 (72, 80) sts.

Purl 2 rnds, then loosely BO all sts.

Repeat for other armhole. Weave in loose ends.

NOTE: The armhole size can easily be adjusted. If you prefer tighter/looser armholes, pick up fewer/more stitches around armholes, use a smaller/larger needle, or BO tightly/loosely.

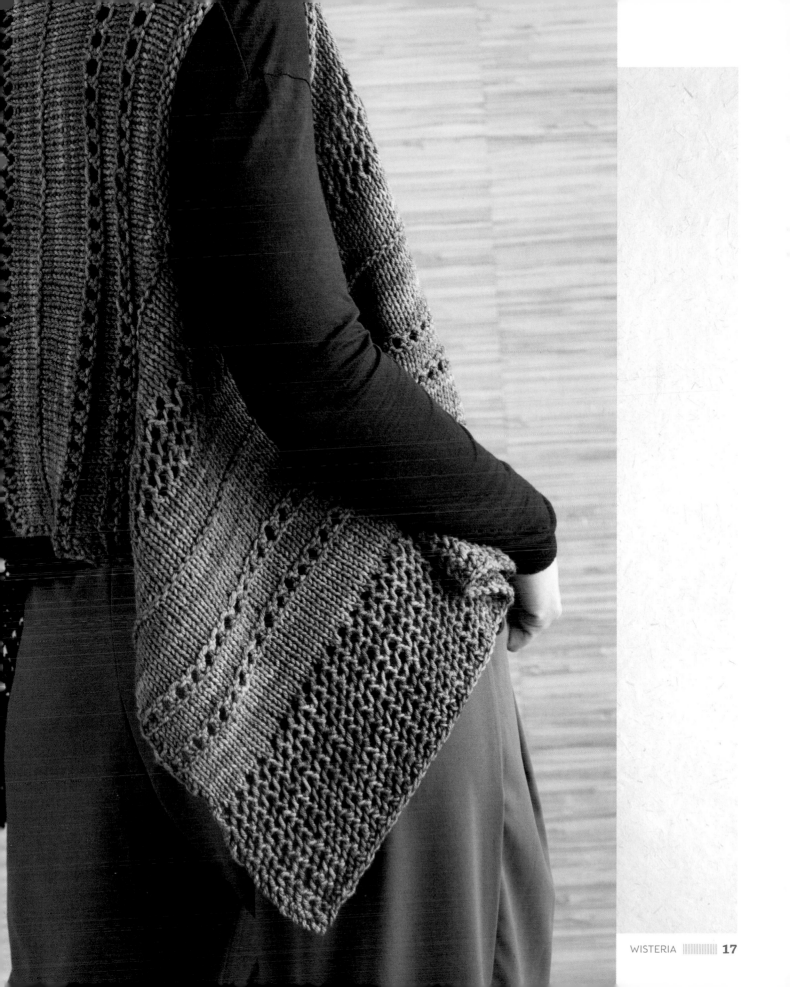

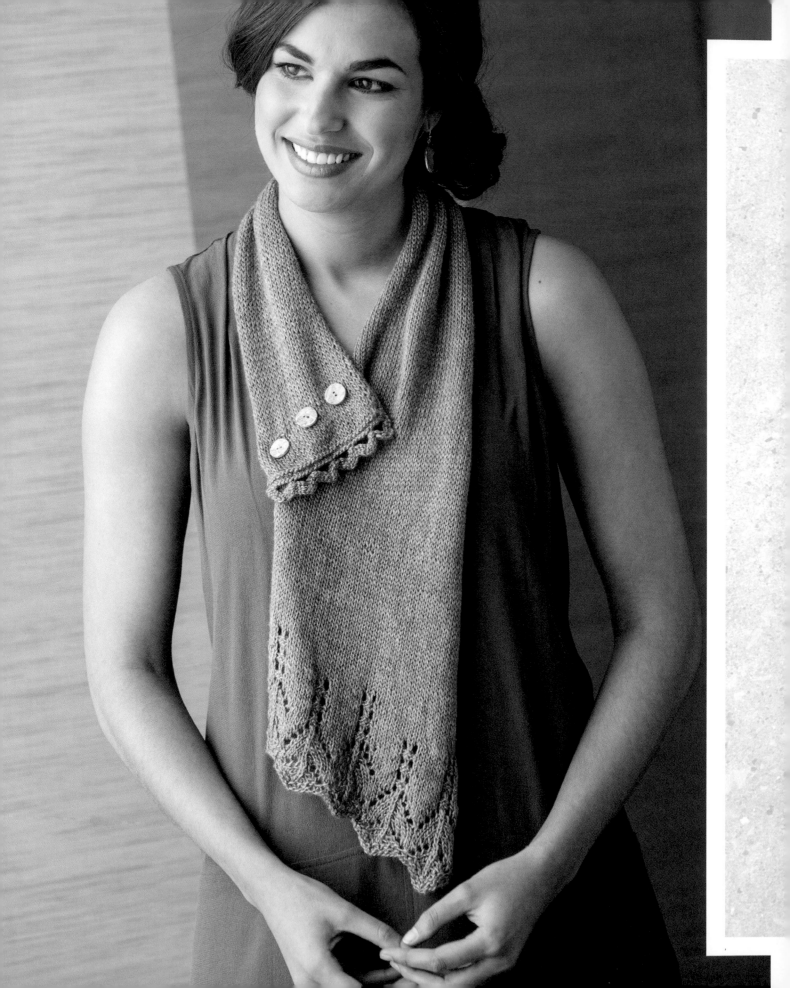

FINISHED SIZE
About 5" to 10½"
(12.5 to 26.5 cm) wide
and 35½" (90 cm) long.

YARN
Sportweight (#2 Fine).

Shown here: Blue Sky
Alpacas Metalico (50%
baby alpaca, 50%
mulberry silk; 147 yd
[134 m]/50 g): #1615
Cinnabar, 2 skeins.

NEEDLES
Size U.S. 6 (4 mm).

*Adjust needle size if
necessary to obtain the
correct gauge.*

NOTIONS
Removable markers (m);
tapestry needle; three
¾" (2 cm) buttons;
sewing needle and
matching thread.

GAUGE
25 sts and 30 rows = 4"
(10 cm) in St st after
blocking.

Field of Wheat

Many of my designs are made from simple shapes such as rectangles and squares, but this scarf is not. The scarf is of varying width, and the angle of the bottom edge is made by gradually casting on stitches, which creates a flowing effect when the scarf is worn. The buttonholes and the eyelet edges are all made using the one-row buttonhole method.

STITCH GUIDE

CENTERED DOUBLE DECREASE (CDD)
Slip 2 sts tog as if to knit, k1, pass 2 slipped stitches over—2 sts dec'd.

SL 1 PWISE WYF
Sl 1 st purlwise with yarn in front (wyf).

4-ST ONE-ROW BUTTONHOLE (4-st BH)
See Glossary

MAKE EYELET (ME)
Bring yarn to front, sl 1 pwise, then return yarn to back. *Sl 1, pass 2nd st over slipped st, and drop it off the needle. Rep from * 3 more times. Sl last st on right needle to left needle and turn work. Bring yarn to back and using the cable cast-on method (see Glossary), CO 8 sts, turn work. Sl 1 from left to right needle and pass last CO st over slipped st.

Instructions

CO 22 sts. Place removable marker (pm) in last st.

ROW 1: (WS) Knit.

ROW 2: (RS) Sl 1 pwise wyf, knit to end.

ROW 3: Knit.

LACE BORDER
ROW 1: (RS) Sl 1 pwise wyf, k1, [yo, k3, CDD, k3, yo, k1] 2 times, pm in last st.

ROW 2: Purl to last 2 sts, k2.

ROW 3: Sl 1 pwise wyf, k1, [k1, yo, k2, CDD, k2, yo, k2] 2 times.

ROW 4: Rep Row 2.

ROW 5: Sl 1 pwise wyf, k1, [k2, yo, k1, CDD, k1, yo, k3] 2 times; pick up and knit 2 sts indicated by m. Remove m and using the cable cast-on method, CO 18 sts—42 sts total. Pm in last st.

ROW 6: K20, purl to last 2 sts, k2.

ROW 7: Sl 1 pwise wyf, k1, [k3, yo, CDD, yo, k4] 2 times, k20.

ROW 8: Rep Row 6.

ROW 9: Sl 1 pwise wyf, k1, [yo, k3, CDD, k3, yo, k1] 4 times, pm in last st.

ROW 10: Purl to last 2 sts, k2.

ROW 11: Sl 1 pwise wyf, k1, [k1, yo, k2, CDD, k2, yo, k2] 4 times.

ROW 12: Rep Row 10.

ROW 13: Sl 1 pwise wyf, k1, [k2, yo, k1, CDD, k1, yo, k3] 4 times; pick up and knit 2 sts indicated by m. Remove m and using the cable cast-on method, CO 19 sts—63 sts total.

ROW 14: Sl 1 pwise wyf, k20, purl to last 2 sts, k2.

ROW 15: Sl 1 pwise wyf, k1, [k3, yo, CDD, yo, k4] 4 times, k21.

ROW 16: Rep Row 14.

ROW 17: Sl 1 pwise wyf, k1, [k3, p3, k4] 2 times, [yo, k3, CDD, k3, yo, k1] 4 times, k1.

ROW 18: Sl 1 pwise wyf, k1, p39, [p4, k3, p3] 2 times, k2.

ROW 19: Sl 1 pwise wyf, k1, [k3, yo, CDD, yo, k4] 2 times, [k1, yo, k2, CDD, k2, yo, k2] 4 times, k1.

ROW 20: Sl 1 pwise wyf, k1, purl to last 2 sts, k2.

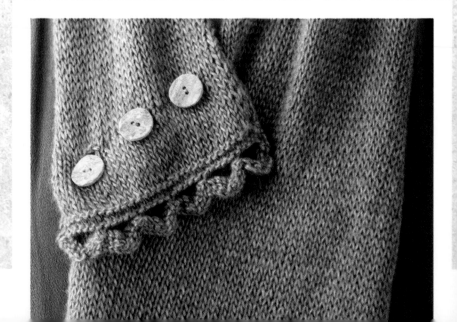

ROW 21: Sl 1 pwise wyf, k1, [k3, p3, k4] 2 times, [k2, yo, k1, CDD, k1, yo, k3] 4 times, k1.

ROW 22: Sl 1 pwise wyf, k1, p39, [p4, k3, p3] 2 times, k2.

ROW 23: Sl 1 pwise wyf, k1, [k3, yo, CDD, yo, k4] 6 times, k1.

ROW 24: Rep Row 20.

ROW 25: Sl 1 pwise wyf, k1, [k3, p3, k4] 4 times, [yo, k3, CDD, k3, yo, k1] 2 times, k1.

ROW 26: Sl 1 pwise wyf, k1, p19, [p4, k3, p3] 4 times, k2.

ROW 27: Sl 1 pwise wyf, k1, [k3, yo, CDD, yo, k4] 4 times, [k1, yo, k2, CDD, k2, yo, k2] 2 times, k1.

ROW 28: Rep Row 20.

ROW 29: Sl 1 pwise wyf, k21, [k3, p3, k4] 2 times, [k2, yo, k1, CDD, k1, yo, k3] 2 times, k1.

ROW 30: Sl 1 pwise wyf, k1, p19, [p4, k3, p3] 2 times, p20, k2.

ROW 31: Sl 1 pwise wyf, k21, [k3, yo, CDD, yo, k4] 4 times, k1.

ROW 32: Rep Row 20.

ROW 33: Sl 1 pwise wyf, k21, [k3, p3, k4] 4 times, k1.

ROW 34: Sl 1 pwise wyf, k1, [p3, k3, p4] 4 times, p19, k2.

ROW 35: Sl 1 pwise wyf, k21, [k3, yo, CDD, yo, k4] 4 times, k1.

ROW 36: Rep Row 20.

ROW 37: Sl 1 pwise wyf, k41, [k3, p3, k4] 2 times, k1.

ROW 38: Sl 1 pwise wyf, k1, [p3, k3, p4] 2 times, p39, k2.

ROW 39: Sl 1 pwise wyf, k41, [k3, yo, CDD, yo, k4] 2 times, k1.

ROW 40: Rep Row 20.

Rep Rows 37–40 once more.

MAIN SECTION

ROW 1: (RS) Sl 1 pwise wyf, knit to end.

ROW 2: Sl 1 pwise wyf, k1, purl to last 2 sts, k2.

ROWS 3–10: Rep Rows 1 and 2.

ROW 11: Sl 1 pwise wyf, k1, ssk, knit to last 4 sts, k2tog, k2—2 sts dec'd.

ROW 12: Sl 1 pwise wyf, k1, purl to last 2 sts, k2.

Rep Rows 1–12 fourteen more times—33 sts.

Work Rows 1–10 once more.

NOTE: To make a longer scarf, add repeats of Rows 1 and 2. Each 2-row repeat will increase the length by about ¼" (6 mm).

END

ROW 1: (RS—buttonholes) Sl 1 pwise wyf, k6, [4-st BH (see Stitch Guide), k4] 3 times, knit to end.

ROW 2: (WS) Sl 1 pwise wyf, k1, purl to last 2 sts, k2.

ROW 3: Sl 1 pwise wyf, knit to end.

ROW 4: Sl 1 pwise wyf, k1, purl to last 2 sts, k2.

ROWS 5–6: Rep Rows 3 and 4 twice.

ROWS 7–10: Knit.

ROW 11: K2, [ME] (see Stitch Guide) 6 times, k1.

ROW 12: Knit.

BO all sts.

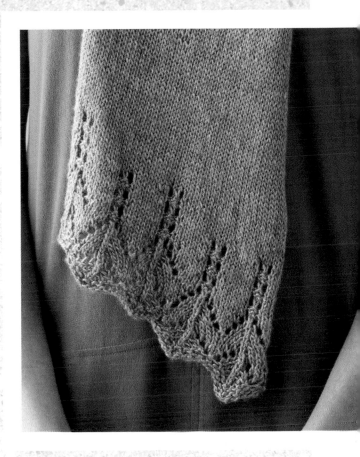

Finishing

Block to measurements. With RS facing, sew first button on left edge 8" (20.5 cm) above CO row. Sew 2nd and 3rd buttons 1⅜" (3.5 cm) apart.

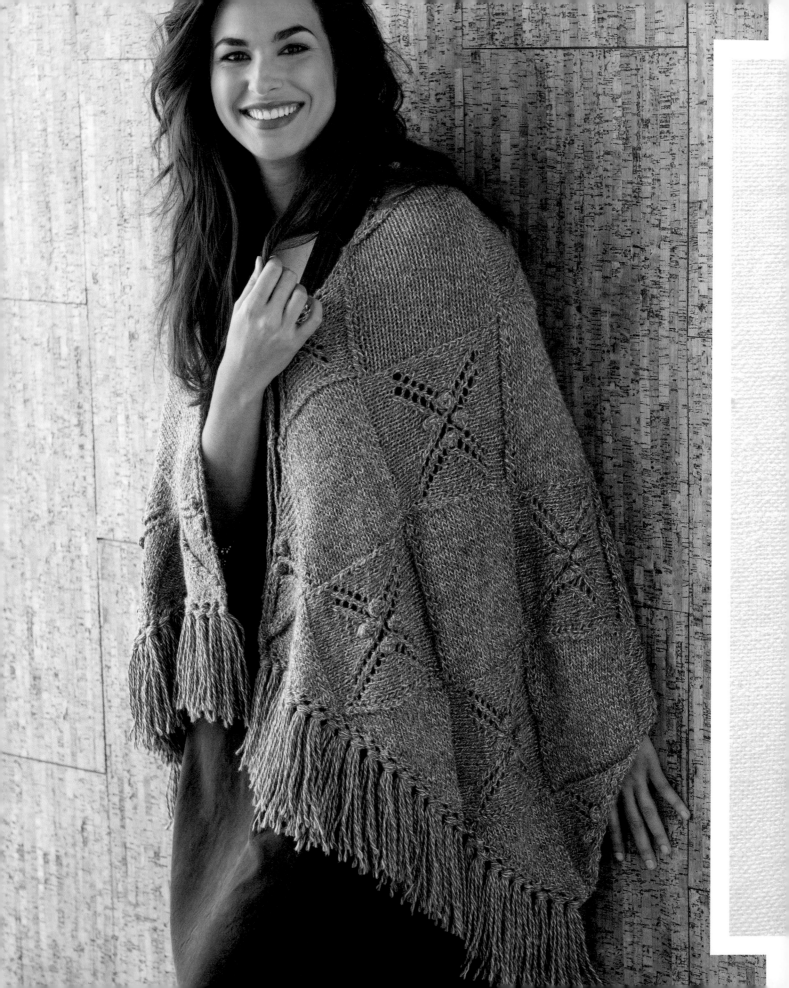

FINISHED SIZE
21½" (54.5 cm) wide
and 51" (129.5 cm) long
without fringe.

YARN
Worsted weight
(#4 Medium).

Shown here: Cascade
Eco Alpaca (100%
baby alpaca; 220 yd
[200 m]/100 g): #1528
Reed Twist, 4 (5) skeins
without (with) fringe.

NEEDLES
Size U.S. 9 (5.5 mm).

Size U.S. 7 (4.5 mm): set
of double-pointed (dpn).

*Adjust needle sizes if
necessary to obtain the
correct gauge.*

NOTIONS
Tapestry needle; size
7mm crochet hook for
fringe.

GAUGE
16 sts and 24 rows = 4"
(10 cm) in St st on larger
needles after blocking.

English Garden

This entrelac shawl is knitted with larger squares to give it a fresh look. The combination of stockinette squares and textured squares gives a special elegant touch. It can be tied to wear as a capelet or left untied as a beautiful wrap.

STITCH GUIDE

SL 2, K1, P2SSO
Sl 2 sts as if to k2tog, k1, pass 2 slipped sts over—2 sts dec'd.

SL 1, K4TOG, PSSO
Sl 1 st as if to knit, knit 4 sts tog, pass slipped st over k4tog—4 sts dec'd.

MAKE BOBBLE (MB)
Work [[yo,k1] twice, k1] all in the same st—5 sts made from 1 st. Turn work, p5, turn work, k5, turn work, p5, turn work, (sl 1, k4tog, psso).

WRAP AND TURN (w&t)
Bring yarn to front between needles, slip next st purlwise to right needle, bring yarn to back between the needles, return slipped st to left needle, turn work.

WORK WRAP TOGETHER WITH WRAPPED STITCH
Insert right needle tip into the wrap from front to back, lift it onto the left needle, then knit the wrap together with the wrapped st.

Instructions

CO 63 sts.

ROW 1: Knit.

ROW 2: K1, *k2tog, yo; rep from * to last 2 sts, k2.

ROW 3: Knit.

BASE TRIANGLES

ROW 1: (RS) K2, turn work around leaving rem sts unworked.

ROW 2: (WS) P2, turn.

ROW 3: K3, turn.

ROW 4: P3, turn.

ROW 5: K4, turn.

ROW 6: P4, turn.

ROWS 7–38: Cont as established working 1 more st every other row.

ROW 39: (RS) K21, do not turn—first base triangle completed.

With RS still facing and 21 sts on right needle, work Row 1 across next 2 sts on left needle.

Work Rows 2–39—2nd base triangle completed.

With RS still facing and 42 sts on right needle, work Row 1 across next 2 sts on left needle.

Work Rows 2–39 once more—3rd base triangle completed; all 63 sts have been worked.

TIER ONE
(right-slanting textured squares with textured side triangles)

Turn work so WS is facing.

Left Triangle
When working p2tog on WS rows, you are joining the side triangle with the sts of the base triangle below it.

SET-UP ROW: (WS) P1f&b (see Glossary), p2tog, turn.

Work Rows 1–36 from written instructions below or from Left Triangle chart.

ROW 1: (RS) K3, turn.

ROW 2: P1f&b, p1, p2tog, turn.

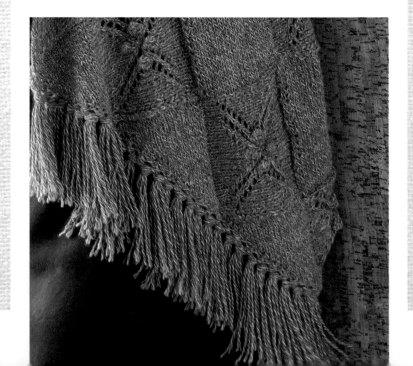

LEFT TRIANGLE

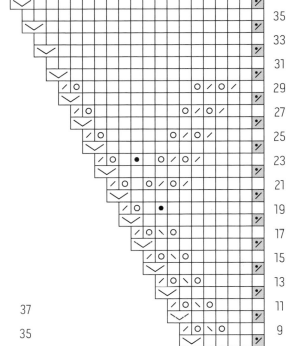

3 sts inc'd to 21 sts

RIGHT TRIANGLE

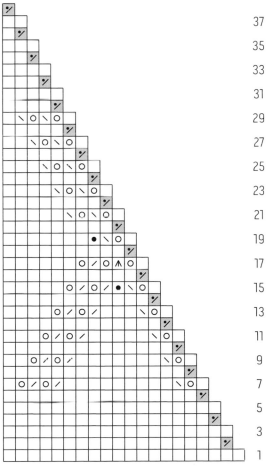

20 sts dec'd to 1 st

	k on RS; p on WS
o	yo
/	k2tog
\	ssk
ʌ	sl 2 as if to k2tog, k1, p2sso
⟩	p2tog
⌣	p1f&b
●	MB (see Stitch Guide)
▨	joining st

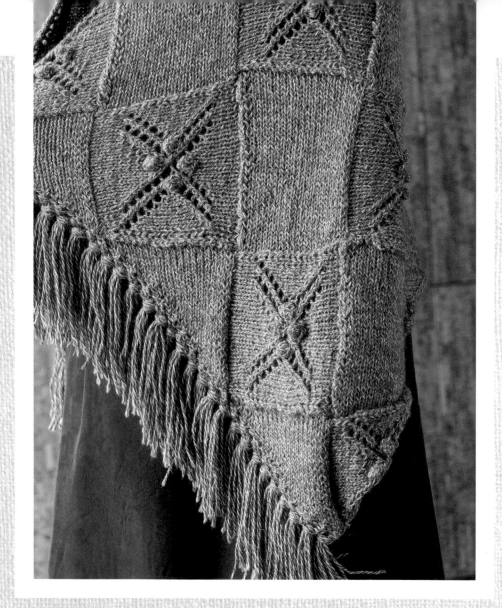

ROW 3: K4, turn.

ROW 4: P1f&b, p2, p2tog, turn.

ROW 5: K5, turn.

ROW 6: P1f&b, p3, p2tog, turn.

ROW 7: K2, yo, ssk, yo, k2tog, turn.

ROW 8: P1f&b, p4, p2tog, turn.

ROW 9: K3, yo, ssk, yo, k2tog, turn.

ROW 10: P1f&b, p5, p2tog, turn.

ROW 11: K4, yo, ssk, yo, k2tog, turn.

ROW 12: P1f&b, p6, p2tog, turn.

ROW 13: K5, yo, ssk, yo, k2tog, turn.

ROW 14: P1f&b, p7, p2tog, turn.

ROW 15: K6, yo, ssk, yo, k2tog, turn.

ROW 16: P1f&b, p8, p2tog, turn.

ROW 17: K7, yo, ssk, yo, k2tog, turn.

ROW 18: P1f&b, p9, p2tog, turn.

ROW 19: K8, MB (see Stitch Guide), k1, yo, k2tog, turn.

ROW 20: P1f&b, p10, p2tog, turn.

ROW 21: K6, [k2tog, yo] twice, k1, yo, k2tog, turn.

ROW 22: P1f&b, p11, p2tog, turn.

ROW 23: K5, [k2tog, yo] twice, k1, MB, k1, yo, k2tog, turn.

ROW 24: P1f&b, p12, p2tog, turn.

ROW 25: K4, [k2tog, yo] twice, k5, yo, k2tog, turn.

ROW 26: P1f&b, p13, p2tog, turn.

ROW 27: K3, [k2tog, yo] twice, k7, yo, k2tog, turn.

ROW 28: P1f&b, p14, p2tog, turn.

ROW 29: K2, [k2tog, yo] twice, k9, yo, k2tog, turn.

ROW 30: P1f&b, p15, p2tog, turn.

ROW 31: K18, turn.

ROW 32: P1f&b, p16, p2tog, turn.

ROW 33: K19, turn.

ROW 34: P1f&b, p17, p2tog, turn.

ROW 35: K20, turn.

ROW 36: P1f&b, p18, p2tog, do not turn—first side triangle completed; 21 sts on right needle.

First Square

SET-UP ROW: With WS facing, pick up and purl 21 sts along the selvedge of the base triangle, sl last st back to left needle, p2tog, turn.

Work Rows 1–40 from written instructions below or from Square chart.

ROW 1: (RS) K21, turn.

ROW 2: (WS) P20, p2tog, turn.

ROWS 3–8: Rep Rows 1 and 2.

ROW 9: K2, [yo, ssk] twice, k9, [k2tog, yo] twice, k2, turn.

ROW 10 AND ALL EVEN-NUMBERED ROWS: P20, p2tog, turn.

ROW 11: K3, [yo, ssk] twice, k7, [k2tog, yo] twice, k3, turn.

ROW 13: K4, [yo, ssk] twice, k5, [k2tog, yo] twice, k4, turn.

ROW 15: K5, [yo, ssk] twice, k3, [k2tog, yo] twice, k5, turn.

ROW 17: K6, [yo, ssk] twice, MB, [k2tog, yo] twice, k6, turn.

ROW 19: K7, yo, ssk, yo, (sl 2, k1, psso), yo, k2tog, yo, k7, turn.

ROW 21: K8, MB, k1, yo, ssk, MB, k8, turn.

ROW 23: K6, [k2tog, yo] twice, k1, [yo, ssk] twice, k6, turn.

ROW 25: K5, [k2tog, yo] twice, k1, MB, k1, [yo, ssk] twice, k5, turn.

ROW 27: K4, [k2tog, yo] twice, k5, [yo, ssk] twice, k4, turn.

ROW 29: K3, [k2tog, yo] twice, k7, [yo, ssk] twice, k3, turn.

ROW 31: K2, [k2tog, yo] twice, k9, [yo, ssk] twice, k2, turn.

ROWS 32–39: Work Row 2, then rep Rows 1 and 2.

ROW 40: P20, p2tog, do not turn—first square completed; 42 sts on right needle, 21 sts of last base triangle on left needle.

Second Square

Repeat first square section— 63 sts on right needle, no sts on left needle.

Right Triangle

SET-UP ROW: With WS facing, pick up and purl 20 sts along the selvedge of the base triangle, turn.

Work Rows 1–38 from written instructions below or from Right Triangle chart.

SQUARE

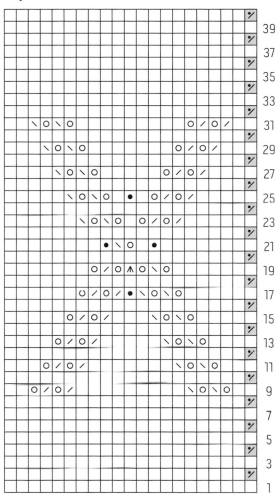

21 sts

☐ k on RS; p on WS

⊙ yo

╱ k2tog

╲ ssk

⋀ sl 2 as if to k2tog, k1, p2sso

⅃ p2tog

● MB (see Stitch Guide)

▨ joining st

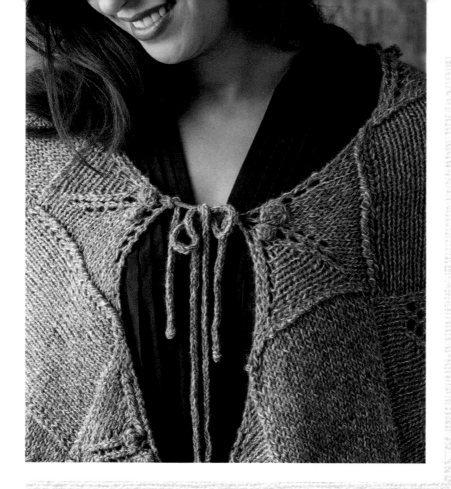

ROW 1: (RS) K20, turn.

ROW 2 AND ALL EVEN-NUMBERED ROWS: Purl to last 2 sts, p2tog, turn.

ROW 3: K19, turn.

ROW 5: K18, turn.

ROW 7: K1, yo, ssk, k9, [k2tog, yo] twice, k1, turn.

ROW 9: K1, yo, ssk, k7, [k2tog, yo] twice, k2, turn.

ROW 11: K1, yo, ssk, k5, [k2tog, yo] twice, k3, turn.

ROW 13: K1, yo, ssk, k3, [k2tog, yo] twice, k4, turn.

ROW 15: K1, yo, ssk, MB, [k2tog, yo] twice, k5, turn.

ROW 17: K1, yo, (sl 2, k1, psso), yo, k2tog, yo, k6, turn.

ROW 19: K1, yo, ssk, MB, k7, turn.

ROW 21: K1, [yo, ssk] twice, k5, turn.

ROW 23: K1, [yo, ssk] twice, k4, turn.

ROW 25: K1, [yo, ssk] twice, k3, turn.

ROW 27: K1, [yo, ssk] twice, k2, turn.

ROW 29: K1, [yo, ssk] twice, k1, turn.

ROW 31: K5, turn.

ROW 33: K4, turn.

ROW 35: K3, turn.

ROW 37: K2, turn.

ROW 38: P2tog, turn—64 sts total on needles.

TIER TWO

(left-slanting solid squares, no side triangles)

***SET-UP ROW:** With RS facing, k1, pick up and knit 20 sts along the selvedge of the side triangle, k1 from rightmost square, slip 2nd st on right needle over first st, turn.

ROW 1: (WS) P21, turn.

ROW 2: K20, sl 1, k1 from rightmost square, psso, turn.

ROWS 3–40: Rep Rows 1 and 2 until 21 sts from right square have been worked—21 sts on right needle.

Rep from * twice more—63 sts on right needle; all sts have been worked; 3 left-slanting squares.

Work Tier 1 and Tier 2 four more times and then Tier 1 once more. Note that you will pick up sts along squares instead of base triangles.

Top Triangles

***SET-UP ROW:** With RS facing, k1, pick up and knit 20 sts along the selvedge of the side triangle, k1 from rightmost square, slip 2nd st on right needle over first st, turn.

ROW 1: (WS) P20, w&t (see Stitch Guide).

ROW 2: K20, sl 1, k1 from rightmost square, psso, turn.

ROW 3: P19, w&t.

ROW 4: K20, sl 1, k1 from rightmost square, psso, turn.

ROWS 5–39: Cont as established purling 1 fewer st on WS rows until 20 sts have been wrapped.

ROW 40: K20, sl 1, k1, psso, do not turn.

Rep from * twice more—63 sts total on needles.

Edging

ROW 1: *K1, [work wrap together with wrapped stitch] 20 times (see Stitch Guide); rep from * across row—63 sts.

ROW 2: K1, *k2tog, yo; rep from * to last 2 sts, k2.

ROW 3: Knit.

BO all sts loosely.

Ties

I-cord (make 2)

With dpn, CO 2sts. Work I-cord (see Glossary) until piece measures 25" (63.5 cm). BO sts.

Place shawl on flat surface with RS facing and longer edge on top. There are 6 side triangles along the top edge; the I-cords will be tied to the 2nd and 5th side triangles.

Fold first I-cord 7" (18 cm) from end and thread longer end from WS to RS through an eyelet of 2nd side triangle. Thread shorter end from WS to RS through next eyelet. Pull both ends of I-cord through folded loop and pull tight. Tie 2 overhand knots in the end of I-cord.

Rep to attach 2nd I-cord to 5th side triangle along the top edge.

Use the longer ends to tie the shawl closed when you wear it as a capelet.

FRINGE (optional)

Attach 30 tassels (instructions below) evenly spaced across eyelets above CO edge. Rep for BO edge.

Tassel (make 60)

Cut 7 strands of yarn about 11" (28 cm) long—you can wind yarn around a DVD case that is 5½" (14 cm) wide. Hold 7 strands tog and fold in half. With RS facing, insert crochet hook from WS to RS into eyelet above the CO (or BO) edge of shawl and pull folded ends of strands through to form loop. Thread ends of strands through loop and pull ends tight.

Finishing

Block lightly. Weave in loose ends.

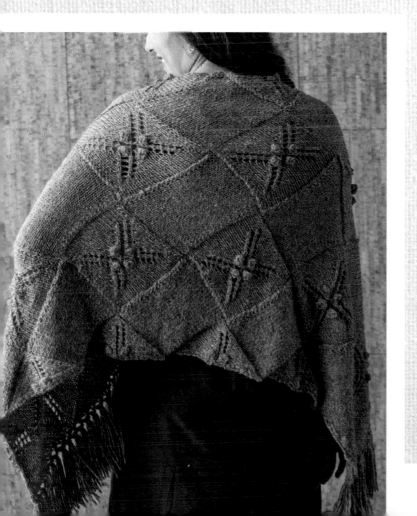

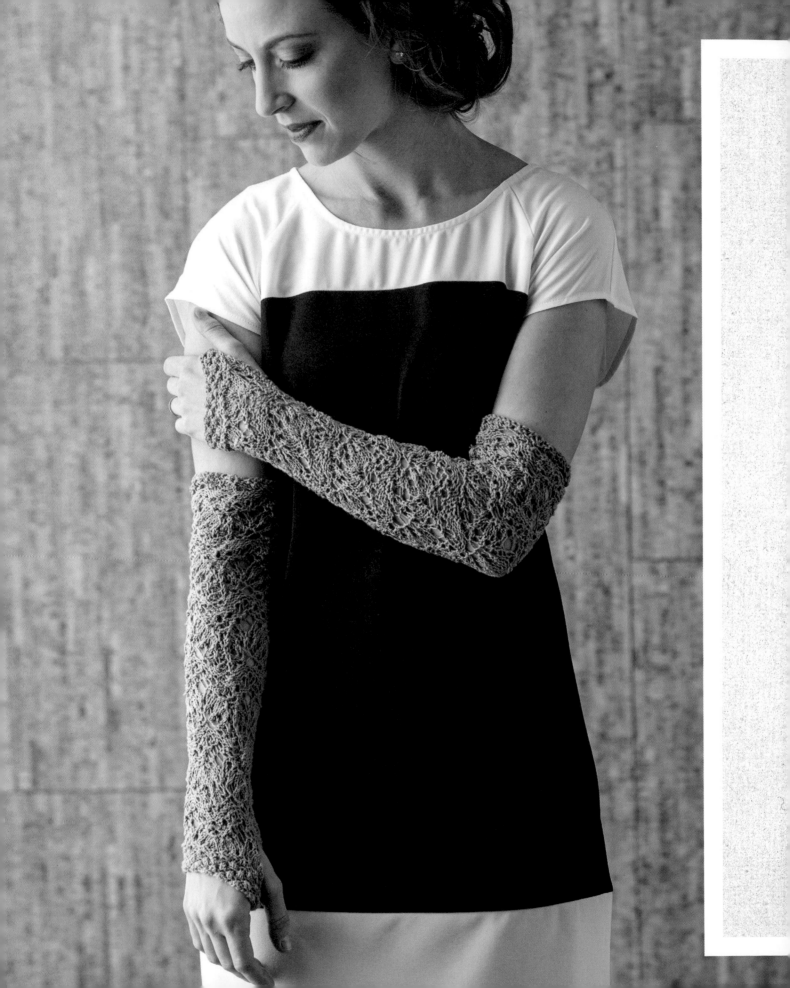

FINISHED SIZE
About 7" to 7¾" (18 to 19.5 cm) circumference and 15¼" (38.5 cm) long.

Mitts will stretch to 10" (25.5 cm) circumference.

YARN
Fingering weight (#1 Super Fine).

Shown here: HiKoo CoBaSi (55% cotton, 16% bamboo, 8% silk, 21% elastic nylon; 220 yd [201 m]/50 g): #008 Natural Olive, 2 skeins.

NEEDLES
Size U.S. 4 (3.5 mm).
Size U.S. 5 (3.75 mm).
Size U.S. 6 (4 mm).

Adjust needle sizes if necessary to obtain the correct gauge.

NOTIONS
Removable stitch markers (m); tapestry needle.

GAUGE
27½ sts and 33 rows = 4" (10 cm) in main patt from chart with middle-size needles.

25 sts and 29 rows = 4" (10 cm) in main patt from chart with largest needles.

Lace Lichen

I use these arm warmers to protect my skin from the sun while I am driving my car and to keep me warm from air-conditioning at the coffee shop and supermarket. These are pretty for summer and much more convenient than a cardigan. I also wear these so they show a little around my wrists when I am layering clothes for spring and fall. When knitting these, changing the needle sizes allows for a wider circumference at the elbow than at the finger cuff.

STITCH GUIDE

SL 1, K2TOG, PSSO
Sl 1 st as if to knit, k2tog, pass slipped st over—2 sts dec'd.

BERRY STITCH PATTERN
(multiple of 4 sts + 2)

ROW 1: (RS) Purl.

ROW 2: P1, *p3tog, (k1, p1, k1) all in same st; rep from * to last st, p1.

ROW 3: Purl.

ROW 4: P1, *(k1, p1, k1) all in same st, p3tog; rep from * to last st, p1.

Rep Rows 1–4 for patt.

MAIN PATTERN
(multiple of 12 sts + 2)

ROW 1: (RS) K1, *yo, k2tog; rep from * to last st, k1.

ROW 2: K1, purl to last st, k1.

ROW 3: Knit.

ROW 4: K1, purl to last st, k1.

ROW 5: K1, *sl 1, k2tog, psso, k4, yo, k1, yo, k4; rep from * to last st, k1.

ROWS 6 AND 7: K1, *p3tog, p4, yo, p1, yo, p4; rep from * to last st, k1.

ROW 8: K1, *sl 1, k2tog, psso, k4, yo, k1, yo, k4; rep from * to last st, k1.

ROW 9: K1, *p3tog, p4, yo, p1, yo, p4; rep from * to last st, k1.

ROWS 10–18: Rep Rows 1–9.

Rep Rows 1–18 for patt.

Instructions

NOTE: Both arm warmers are worked the same and can be worn on either hand.

FINGER CUFF
With smallest needles, CO 50 sts.

Work Rows 1–4 of Berry Stitch patt (see Stitch Guide) twice.

NEXT ROW: Purl.

NEXT ROW: Knit.

Place marker (pm) in the first and last sts of row just worked.

MAIN SECTION
Change to middle-size needles.

ROWS 1–18: Work Main patt (from Stitch Guide or chart), placing marker in the first and last sts of Row 9.

Work Main patt 2 more times.

ELBOW
Change to largest needles.

Work Rows 1–18 of Main patt 3 times.

NEXT ROW (RS): Purl.

NEXT ROW: Knit.

Loosely BO all sts.

Rep instructions to make 2nd arm warmer.

MAIN PATTERN

12-st repeat

☐ k on RS; p on WS		⋏ sl 1, k2tog, psso
• p on RS; k on WS		✕ p3tog
○ yo		☐ pattern repeat
╱ k2tog		

Finishing

With RS facing, fold each arm warmer in half lengthwise. Matching markers from end of finger cuff, sew edges together using mattress stitch (see Glossary) from CO edge to markers. Matching markers from main section, sew edges together from markers to BO edge (the remaining unsewn edge sts constitute the thumb opening).

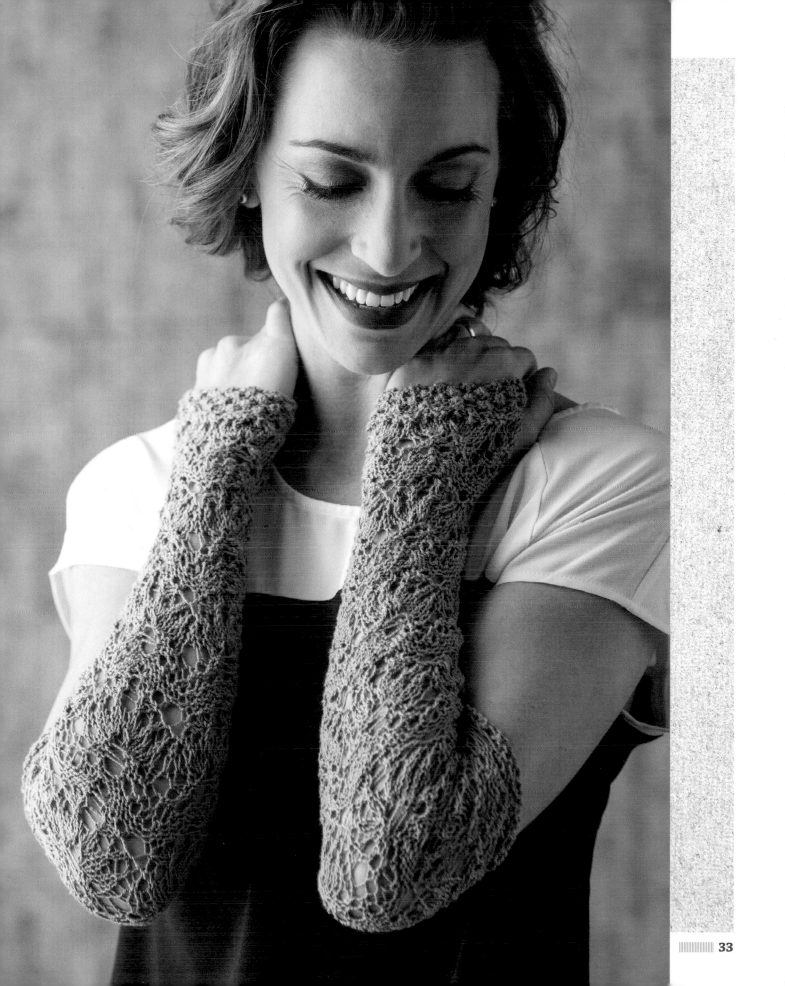

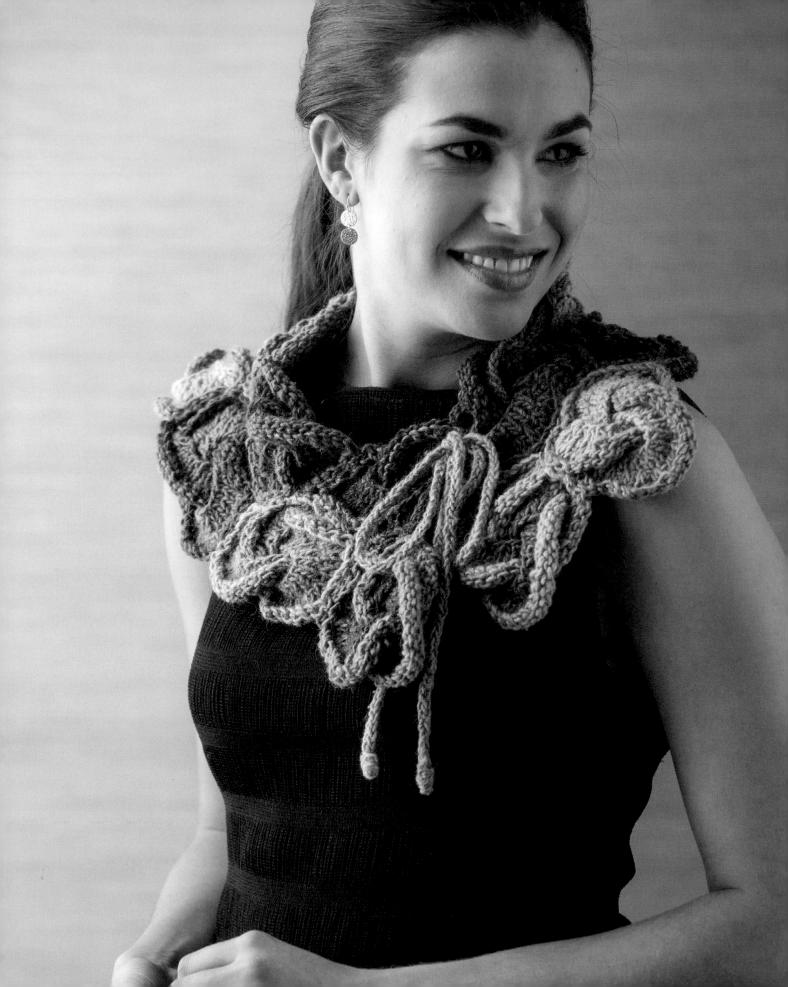

FINISHED SIZE
About 31½" (80 cm) long
and 7" (18 cm) wide.

YARN
Worsted weight (#4
Medium).

Shown here: Cascade
Casablanca (55% wool,
26% silk, 19% mohair;
220 yd [200 m]/100 g):
#01 Neutrals, 2 skeins.

NEEDLES
Size U.S. 9 (5.5 mm).

Size U.S. 7 (4.5 mm): set
of double-pointed (dpn)
for I-cord.

*Adjust needle sizes if
necessary to obtain the
correct gauge.*

NOTIONS
Tapestry needle.

GAUGE
Each pansy motif is about
4½" (11.5 cm) in diameter
before seaming.

Pansies

I wanted to design a ruffled scarf, so I made a short ruffled strip for a sample and tied it in a loose overhand knot so it would fit easily in my small project bag. A few days later, I took out the knotted strip, and it looked like a flower motif, so I decided to make more and create a scarf with them. Unlike many knitted motifs that are complicated and require double-pointed needles, this motif is simple and easy to make. Knotting it gives dimension, and self-striping yarn makes the colors flow like they do in a pansy.

Instructions

PANSY MOTIF (make 15)

Leaving a 6" to 8" (15 to 20.5 cm) tail, CO 37 sts with larger needles—this counts as Row 1.

ROW 2: Purl.

ROW 3: Knit.

ROW 4: Purl.

ROW 5: [K1f&b] 37 times —74 sts.

ROW 6: Purl.

ROW 7: Knit.

ROW 8: Purl.

Loosely BO all sts leaving a 15" to 17" (38 to 43 cm) tail and cut yarn.

With RS facing, hold both ends of the strip and tie loosely in an overhand knot. Using BO tail, sew the first and the last BO sts together to make the motif. This tail will also be used when connecting motifs, so do not cut or weave it in yet.

Layer the beginning of CO edge, the end of CO edge, and the knitted fabric that is adjacent to those. Using CO tail, sew these 3 layers together to create pansy shape. Weave in CO tail.

CONNECT MOTIFS

Arrange all motifs per schematic (below). Using BO tail of each motif and with RS facing, put WS together and use running st to join motifs together where the BO edges touch. Note that each seam should be 1 row in from BO edge so that it will show on the RS, and the edges of each motif stay curly.

TIE

Using dpn, CO 2 sts. Work I-cord (see Glossary) until piece measures 45" to 47" (114.5 to 119.5 cm). Leaving a 3" (7.5 cm) tail, cut yarn. For each tail (starting and ending), thread tail on a tapestry needle; draw needle through end sts of I-cord and pull firmly. Tie 2 overhand knots at each end of I-cord.

With RS facing, thread I-cord into center of motif A (see schematic) from front to back and through center of motif B from back to front. Tie I-cord when wearing scarf.

Finishing

Weave in loose ends. Block if desired.

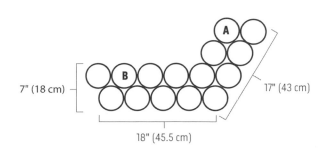

7" (18 cm)

17" (43 cm)

18" (45.5 cm)

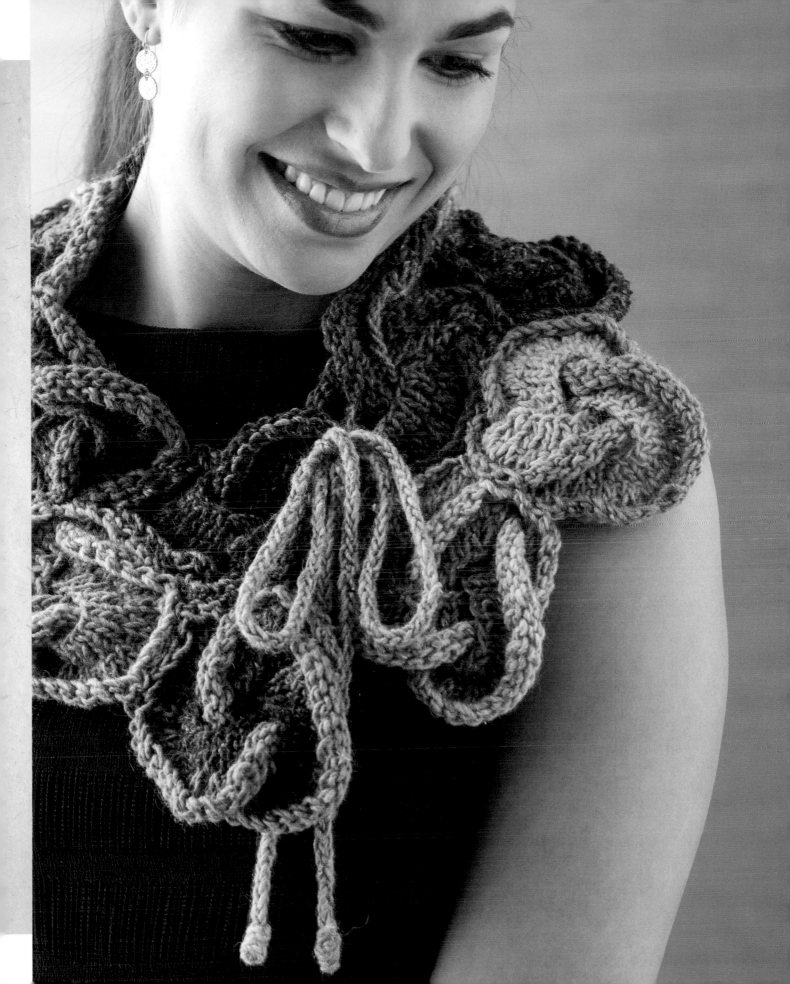

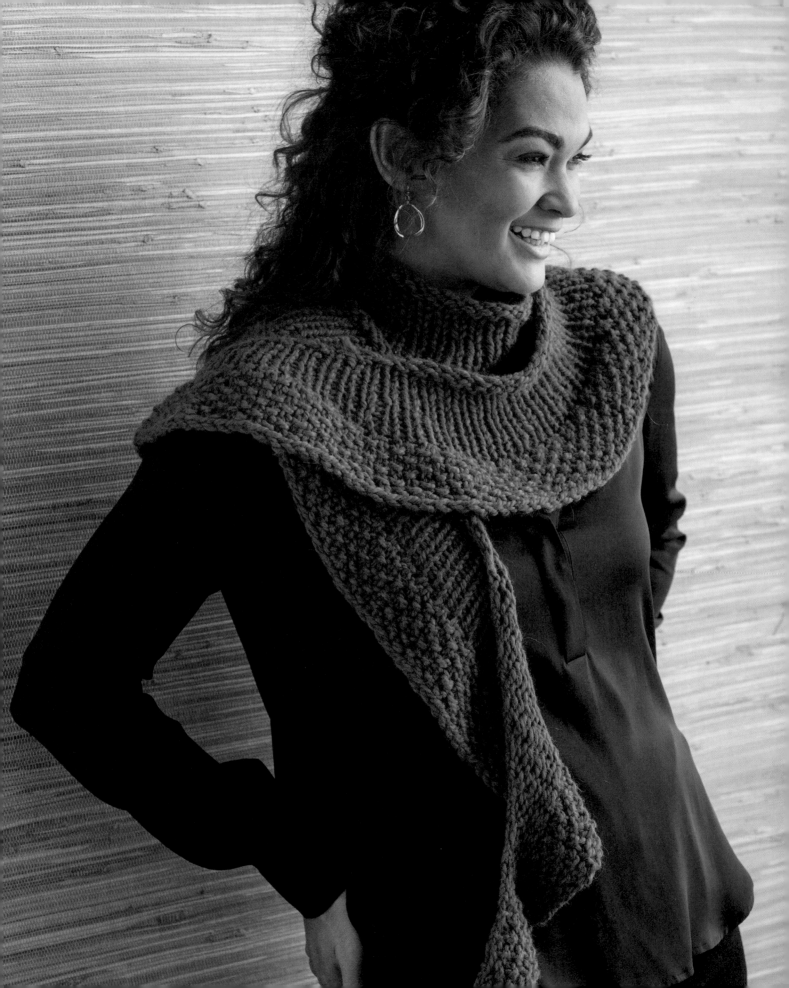

FINISHED SIZE
About 80" (203 cm)
measured along top edge
and 6" (15 cm) wide at
center of top edge.

YARN
Chunky weight
(#5 Bulky).

Shown here: Misti
Alpaca Chunky (100%
baby alpaca; 109 yd
[100 m]/100 g): #707
Copper Melange, 2 skeins.

NEEDLES
Size U.S. 17 (12 mm):
24" (61 cm) or longer
circular (cir).

*Adjust needle size if
necessary to obtain the
correct gauge.*

NOTIONS
Tapestry needle.

GAUGE
6 sts and 14 rows =
4" (10 cm) in St st after
blocking.

Garden Path

This chunky ruffle scarf is a good project for a beginner. There are only knit and purl stitches used in stockinette stitch, reverse stockinette, and seed stitch patterns. The increases at the beginning and end of each row give the scarf its crescent shape.

Instructions

CO 90 sts.

ROW 1 (RS): K1f&b (see Glossary), purl to last st, k1f&b—92 sts.

ROW 2: K1f&b, knit to last st, k1f&b—94 sts.

ROW 3: K1f&b, knit to last st, k1f&b—96 sts.

ROW 4: K1f&b, purl to last st, k1f&b—98 sts.

ROWS 5–14: Rep Rows 3 and 4 five times—118 sts.

ROW 15: *K1f&b; rep from * to end—236 sts.

ROW 16: K1f&b, *k1, p1; rep from * to last st, k1f&b—238 sts.

ROWS 17–22: Rep Row 16 six times—250 sts.

Loosely BO all sts.

Finishing

Weave in loose ends. Block to measurements.

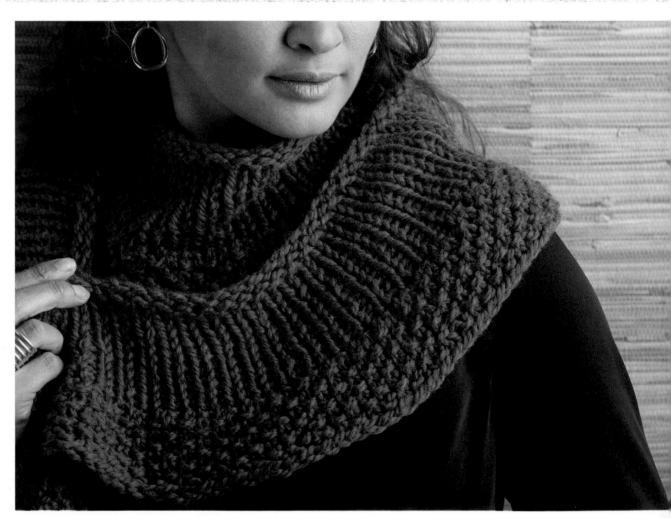

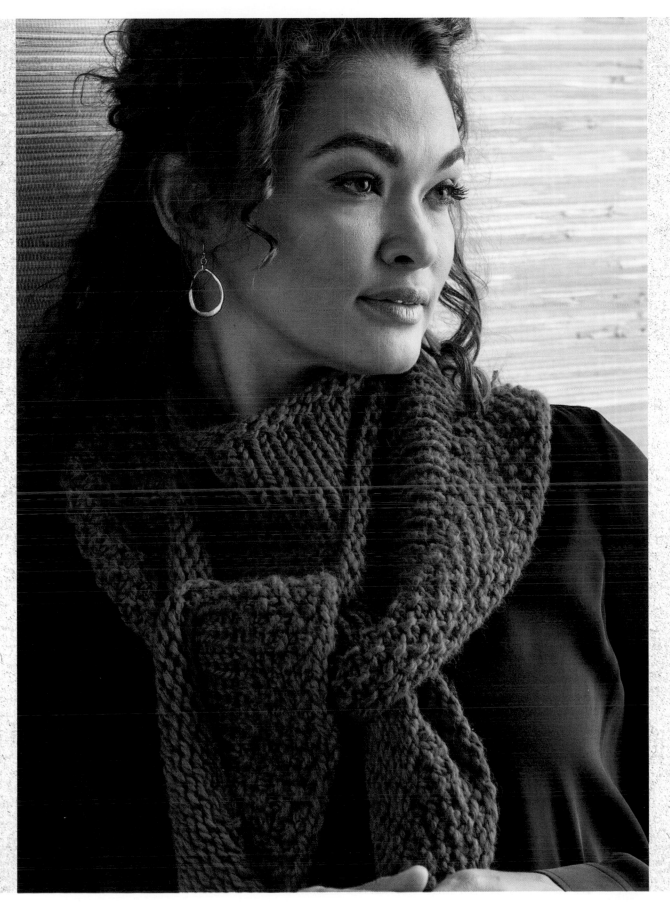

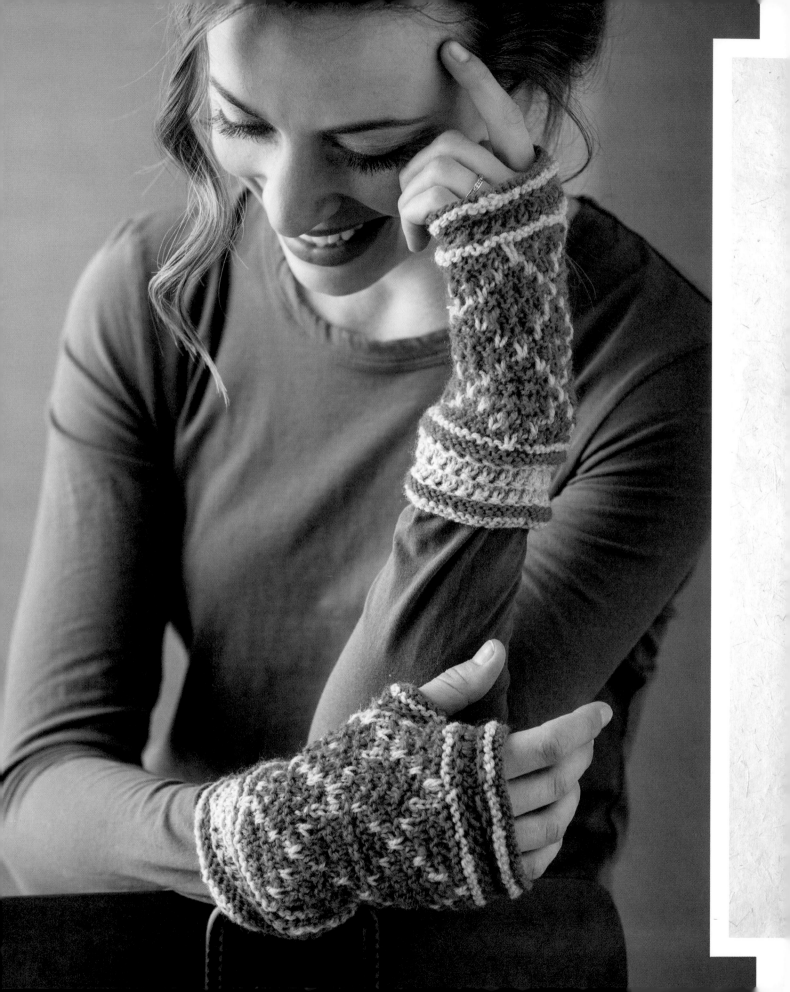

FINISHED SIZE
8" (20.5 cm) circumference and 7" (18 cm) long.

YARN
Sportweight (#2 Fine).

Shown here: Brown Sheep Nature Spun Sport (100% wool, 184 yd [168 m]/50 g): #720 Ash (white; A), #N17 French Clay (orange; B), 1 ball each.

NEEDLES
Size U.S. 5 (3.75 mm): set of 4 double-pointed (dpn).

Size U.S. 4 (3.5 mm): dpn.

Adjust needle sizes if necessary to obtain the correct gauge.

NOTIONS
Tapestry needle; stitch holder or waste yarn.

GAUGE
24 sts and 44 rnds = 4" (10 cm) in Mosaic patt from chart on larger needles.

Lattice

Mosaic stitch patterns are both colorful and textured. Normally they are a little too "busy" for me, so I have not tried many designs with mosaic stitch patterns. When I stumbled upon a simple mosaic tile pattern in a photo, I thought it was very pretty, so I used a mosaic stitch pattern in this small project.

STITCH GUIDE

SL 1 PWISE WYB

Slip 1 st purlwise with yarn in back.

NOTES

—Carry the yarn not in use loosely across the back of the work at the beginning of round, twisting the colors around each other as necessary to prevent long floats from forming.

— Both gloves are worked the same and can be worn on either hand.

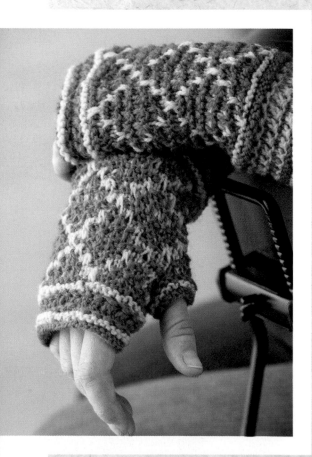

Instructions

CUFF

With A and larger needles, CO 48 sts evenly over 3 dpn. Place marker (pm) and join for working in rnds, being careful not to twist sts.

RND 1: With A, purl 1 rnd.

RND 2: With B, knit 1 rnd.

RNDS 3 AND 4: With B, purl 2 rnds.

RND 5: With A, knit 1 rnd.

RND 6: With A, p2tog 24 times—24 sts.

RND 7: With A, k1f&b (see Glossary) 24 times—48 sts.

RND 8: With A, knit 1 rnd.

RNDS 9–14: Rep Rnds 5–8 once, then work Rnds 5 and 6 once more.

RND 15: With B, k1f&b 24 times—48 sts.

RNDS 16 AND 17: With B, purl 2 rnds.

RND 18: With A, knit 1 rnd.

RND 19: With A, purl 1 rnd.

HAND

RNDS 1–24: Work Rnds 1–24 of Mosaic patt from chart.

RNDS 25–37: Work Rnds 1–13 of Mosaic patt.

RND 38: (thumbhole) P6, sl 1, p2, place 7 thumb sts on stitch holder or waste yarn, use the backward-loop method (see Glossary) to CO 7 sts, p2, sl 1, p5, *p6, sl 1, p5; rep from * to end.

RNDS 39–48: Work Rnds 15–24 of Mosaic patt.

RNDS 49 AND 50: Work Rnds 1 and 2 of Mosaic patt.

MOSAIC PATTERN

☐ knit with A

▲ sl 1 pwise wyb with A

▮ knit with B

⊙ purl with B

△ sl 1 pwise wyb with B

☐ pattern repeat

12-st repeat

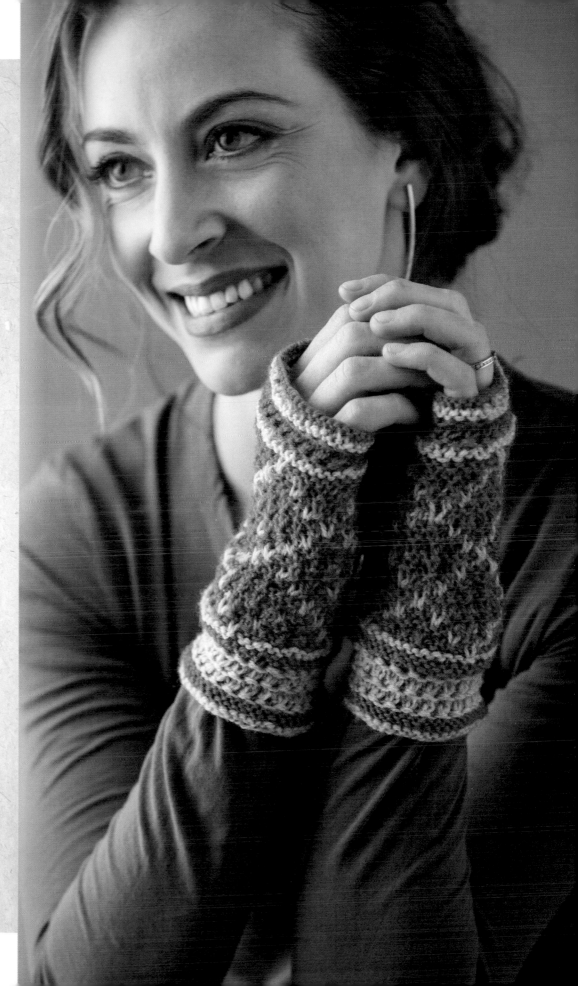

TOP

RND 1: With A, knit 1 rnd.

RND 2: With A, purl 1 rnd.

RND 3: With B, knit 1 rnd.

RND 4: With B, p2tog 24 times—24 sts.

RND 5: With B, k1f&b 24 times—48 sts.

RND 6: With B, knit 1 rnd.

RNDS 7 AND 8: Rep Rnds 3 and 4.

RND 9: Change to smaller needles. With A, k1f&b 24 times—48 sts.

RND 10: With A, purl 1 rnd.

RND 11: With B, knit 1 rnd.

BO all sts purlwise (pwise).

THUMB

Place 7 held thumb sts on larger dpn. With B, knit 7 thumb sts, pick up and knit 1 st from fabric between held sts and CO, pick up and knit 7 sts from base of sts CO over thumb gap, pick up and knit 1 st from fabric between CO and held sts to close gap—16 sts. Arrange sts so that there are 7 sts on Needle 1, 5 sts on Needle 2, and 4 sts on Needle 3.

RND 1: With B, purl 1 rnd.

RND 2: With A, knit 1 rnd.

RND 3: With A, purl 1 rnd.

RND 4: With B, knit 1 rnd.

BO all sts pwise.

Finishing

Weave in loose ends. Block if desired.

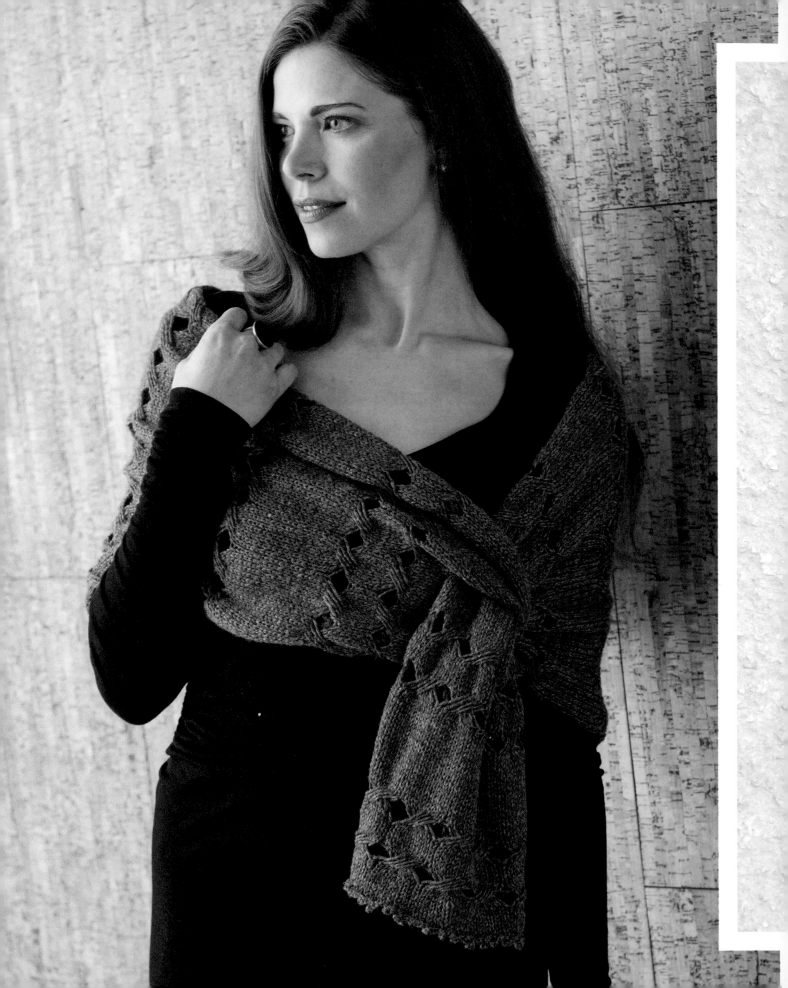

FINISHED SIZE
16½" (42 cm) wide and
48½" (123 cm) long
excluding keyhole.

YARN
DK weight (#3 Light).

Shown here: Rowan
Baby Merino Silk DK
(66% superwash wool,
34% tussah silk; 147 yd
[135 m]/50 g): #SH687
Strawberry, 5 balls.

NEEDLES
Size U.S. 7 (4.5 mm).

*Adjust needle size if
necessary to obtain the
correct gauge.*

NOTIONS
Smooth waste yarn for
provisional cast-on;
tapestry needle.

GAUGE
19½ sts and 27 rows =
4" (10 cm) in St st after
blocking.

Japanese Lanterns

This is a very simple and useful wrap. You can tailor this wrap to your lifestyle by working it in a heavier weight yarn if you live in a cold area, knitting it in linen to protect yourself from air-conditioning in the summertime, or using a shimmery or sparkly yarn for going out at night. The length is easy to adjust if a shorter or longer wrap would be more flattering on you.

STITCH GUIDE

SL 1 PWISE WYF

Slip 1 st purlwise with yarn in front.

INTERLACED STITCH

(multiple of 8 sts + 4)

ROW 1: (WS) Sl 1 pwise wyf, k1, *insert needle into next st to purl and wrap yarn around needle 3 times, then knit the st withdrawing all the wraps along with the needle; rep from * to last 2 sts, k2.

ROW 2: (RS) Sl 1 pwise wyf, k1, *sl 8 sts with yarn in back, dropping all extra wraps and creating 8 long sts on right needle; insert left needle into the first 4 of these 8 long sts and pass them over the 2nd 4 sts; return all sts to left needle and knit sts in new order; rep from * to last 2 sts, k2.

NOTES

— To make a longer or shorter wrap, work the 30-row repeat in the main section more or fewer times. Every 30-row repeat will lengthen or shorten the wrap by about 5½" (14 cm). Or you can simply work more rows in stockinette stitch in the main section to adjust the length.

— You may need more yarn if making a larger wrap.

Instructions

KEYHOLE

Using a provisional method (see Glossary), CO 42 sts (this counts as Row 1).

ROW 2: (WS) Sl 1 pwise wyf (see Stitch Guide), k1, purl to last 2 sts, k2.

ROW 3: Sl 1 pwise wyf, k1, k2tog, knit to last 4 sts, ssk, k2—40 sts (2 sts dec'd).

ROW 4: Sl 1 pwise wyf, k1, purl to last 2 sts, k2.

ROWS 5-18: Rep Rows 3 and 4 seven times—26 sts.

ROW 19: Sl 1 pwise wyf, knit to end.

ROW 20: Sl 1 pwise wyf, k1, purl to last 2 sts, k2.

ROW 21: Sl 1 pwise wyf, k1, M1, knit to last 2 sts, M1, k2—28 sts (2 sts inc'd).

ROW 22: Sl 1 pwise wyf, k1, purl to last 2 sts, k2.

ROWS 23-36: Rep Rows 21 and 22 seven times—42 sts.

MAIN SECTION

SET-UP ROW: Sl 1 pwise wyf, k41, carefully remove waste yarn from provisional CO and place 42 exposed sts on left needle being careful not to twist fabric of keyhole, knit 42 sts on left needle—84 sts.

ROW 1: Sl 1 pwise wyf, k1, purl to last 2 sts, k2.

ROW 2: Sl 1 pwise wyf, knit to end.

ROWS 3-10: Rep Rows 1 and 2 four times.

ROWS 11 AND 12: Work Rows 1 and 2 of interlaced stitch (see Stitch Guide).

ROWS 13-18: Rep Rows 1 and 2 three times.

ROWS 19 AND 20: Work Rows 1 and 2 of interlaced stitch.

ROWS 21-31: Rep Rows 1 and 2 five times.

Work Rows 2–31 eight more times.

BO all sts as follows:

*Using the cable cast-on method (see Glossary), CO 3 sts, then BO 5 sts using the standard bind-off. Sl last st on right needle back to left needle; rep from * until all sts have been bound off.

Finishing

Block wrap. Weave in loose ends.

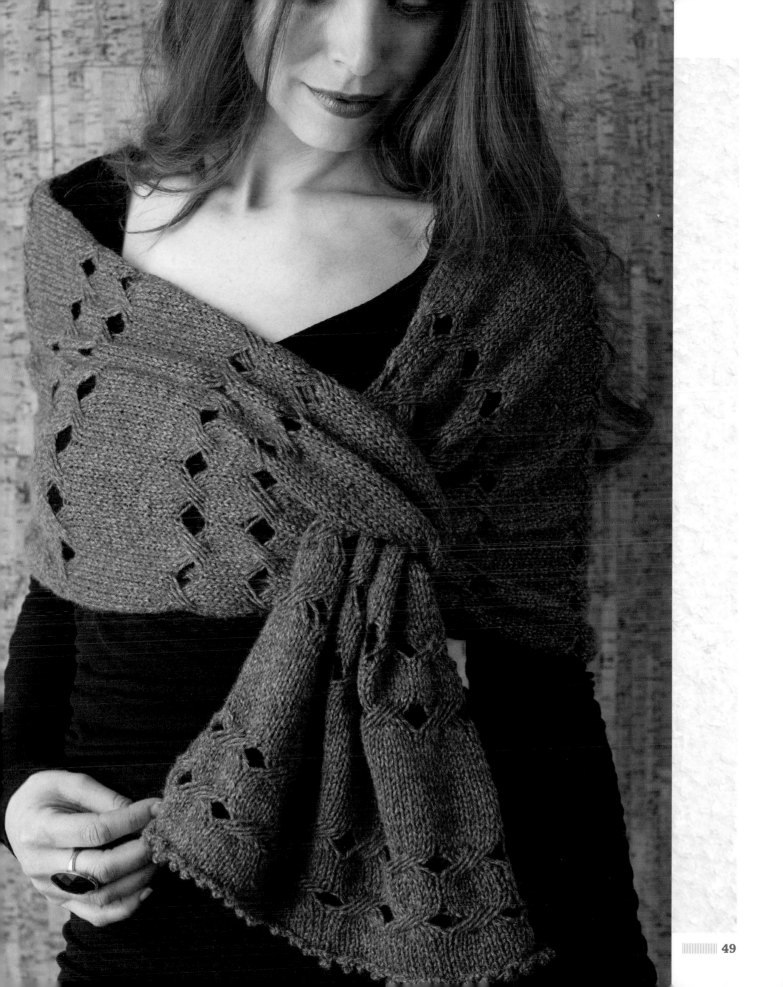

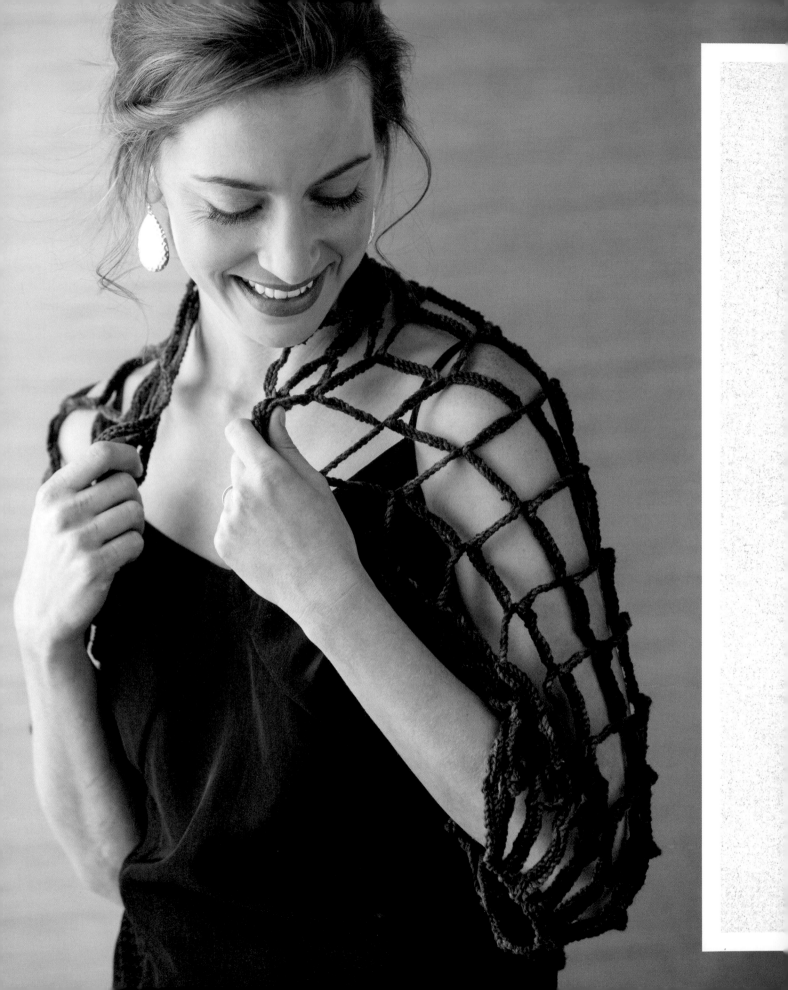

FINISHED SIZE
44½ (50¾, 50¾)"
(113 [129, 129] cm) long
from cuff to cuff and
20 (20, 22½)" (51 [51,
57] cm) high at center
back when worn.

Shrug shown measures
44½" (113 cm).

YARN
DK weight (#3 Light).

Shown here: Misti Alpaca
Tonos Pima Silk (83%
pima cotton, 17% silk;
327 yd [300 m]/100 g);
#TPS03 Night Sea,
2 (2, 2) skeins.

NEEDLES
Size U.S. 7 (4.5 mm).

*Adjust needle size if
necessary to obtain the
correct gauge.*

NOTIONS
Tapestry needle;
removable markers (m).

GAUGE
30½ sts and 7 rows
= 4" (10 cm) in net
stitch pattern.

Midnight Tendril

There are a lot of ways to make buttonholes. I learned the one-row buttonhole method that I think makes the best-looking buttonhole. I used the same method in this shrug pattern. This project is simple to knit because there are only bind-offs and cast-ons throughout this project. The important thing to remember with this pattern is to count the number of stitches with accuracy.

STITCH GUIDE

NOTE: The holes in the shrug are very large buttonholes made over 24 stitches by binding off stitches without knitting them first and then casting on stitches on the same row using the cable cast-on method.

24-ST ONE-ROW BUTTONHOLE (24-st BH)

Bring the yarn to the front of the work, slip the next stitch purlwise, then return the yarn to the back. *Slip the next stitch, pass the 2nd stitch over the slipped stitch and drop it off the needle. Repeat from * 22 more times. Slip the last stitch on the right needle to the left needle and turn the work around. Bring the working yarn to the back, using the cable cast-on method

(see Glossary), CO 24 sts. Turn the work around. With the yarn in back, slip the first stitch and pass the extra cast-on stitch over it and off the needle to complete the buttonhole.

NET STITCH PATTERN

(multiple of 24 sts + 3 with a minimum of 51 sts)

ROW 1: Knit.

ROW 2: K2, *24-st BH; rep from * to last st, k1.

ROW 3: Knit.

ROW 4: K14, *24-st BH; rep from * to last 13 sts, k13.

Rep Rows 1–4 for patt.

NOTE: Use removable markers after working Rows 1 and 3 to identify groups of 24 sts and ensure you are binding off and casting on the correct number of stitches on Rows 2 and 4.

Instructions

CO 339 [387, 387] sts.

Work Rows 1–4 of Net Stitch patt (see Stitch Guide) 8 [9, 9] times. Then work Rows 1 and 2 of Net Stitch patt once. BO all sts.

NOTE: For a wider shrug, cast on 24 more sts. Every 24 sts added will increase the width by about 3⅛" (8 cm). For a longer shrug, work more repeats of the Net Stitch patt. Each repeat added will lengthen the piece by about 2¼" (5.5 cm). Plan to purchase extra yarn if making a bigger shrug.

Finishing

Fold in half lengthwise so that CO and BO edges match (selvedges will become the cuffs).

LEFT CUFF: Sew center of the 2nd loop of CO edge to center of the 2nd loop of BO edge. Rep for right cuff.

NOTE: If you prefer a more fitted look, sew the 2nd loop of the CO edges to the 2nd loop of the BO edges and the 3rd loop of the CO edges to the 3rd loop of the BO edges.

Weave in loose ends.

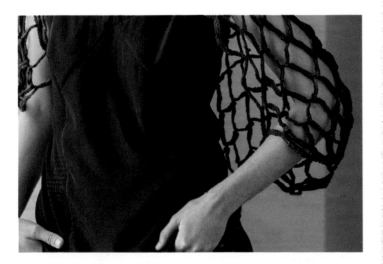

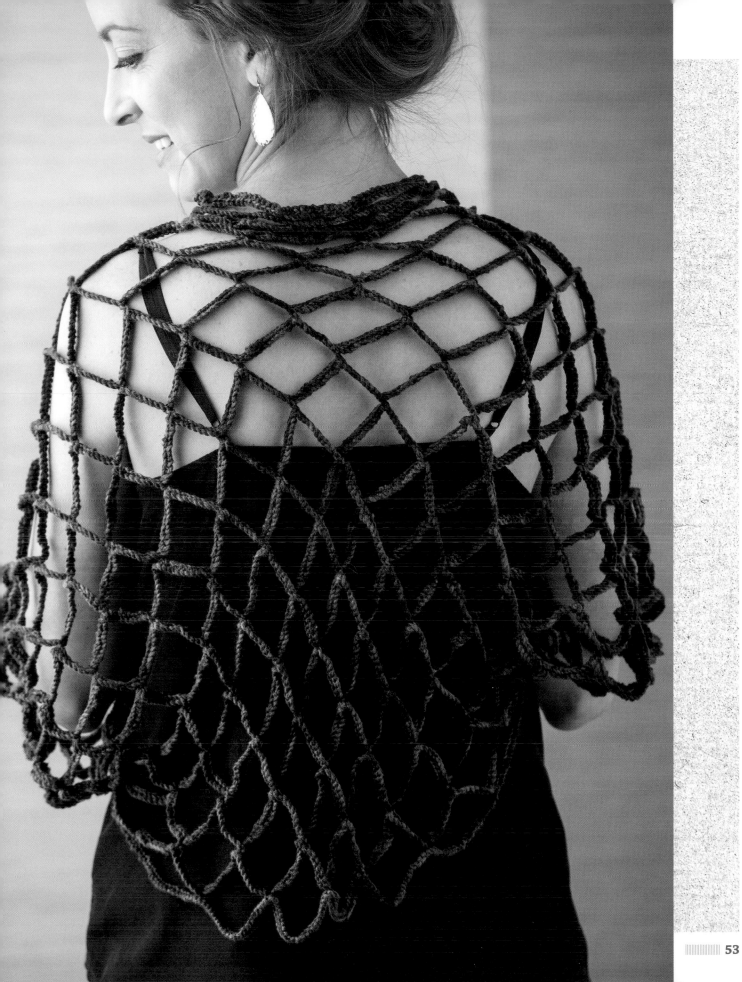

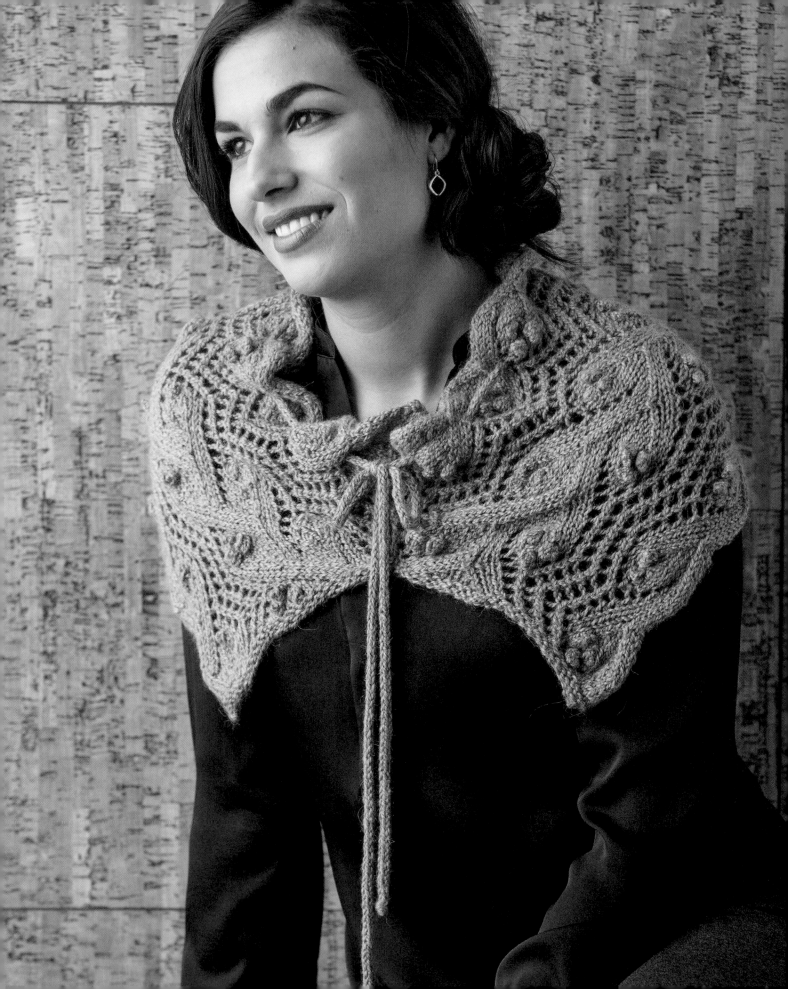

FINISHED SIZE

About 10" (25.5 cm) high and 31" (79 cm) circumference.

YARN

Sportweight (#2 Fine).

Shown here: Blue Sky Alpacas Melange (100% baby alpaca; 110 yd [100 m]/50 g): #807 Dijon, 3 skeins.

NEEDLES

Size U.S. 7 (4.5 mm).

Size U.S. 6 (4 mm): set of double-pointed (dpn).

Adjust needle sizes if necessary to obtain the correct gauge.

NOTIONS

Tapestry needle.

GAUGE

20 sts and 16 rows of Angel Blossom patt = 4¾" (12 cm) wide and 2½" (6.5 cm) long on larger needles after blocking.

Acorns and Ivy

I love this color. I didn't know what I wanted to create with it, but I got the yarn just because of the color. I put this yarn on a table that I often walked by and got ideas every time I saw it. At first I considered a stitch pattern with bobbles, then I added some lace to the bobbles—these two textures are often together in my designs. To show the beautiful stitch pattern and resulting wavy edge, this cowl is not a closed tube but knitted flat and seamed halfway.

STITCH GUIDE

MAKE BOBBLE (MB)

Work ([k1, p1] twice, k1) all in the same st—5 sts made from 1 st. Turn work, p5 with WS facing. Turn work, pass the 2nd, 3rd, 4th, and 5th stitches over first st, then knit the remaining st through the back loop—5 sts dec'd to 1 st again.

SL 1, K2TOG, PSSO

Slip 1 st as if to knit, k2tog, pass slipped stitch over—2 sts dec'd.

SL 1 PWISE WYF

Slip 1 st purlwise with yarn in front.

ANGEL BLOSSOM PATTERN

(multiple of 20 sts + 7)

ROW 1: (RS) Sl 1 pwise wyf (see Stitch Guide), k5, *yo, k1, yo, [ssk, yo] 3 times, k2, ssk, k5, k2tog, k2; rep from * to last st, k1.

ALL EVEN-NUMBERED ROWS: Sl 1 pwise wyf, purl to last st, k1.

ROW 3: Sl 1 pwise wyf, k5, *yo, k3, yo, [ssk, yo] 3 times, k2, ssk, k3, k2tog, k2; rep from * to last st, k1.

ROW 5: Sl 1 pwise wyf, k5, *yo, k2, MB, k2, yo, [ssk, yo] 3 times, k2, ssk, k1, k2tog, k2; rep from * to last st, k1.

ROW 7: Sl 1 pwise wyf, k5, *yo, k2, MB, k1, MB, k2, yo, [ssk, yo] 3 times, k2, (sl 1, k2tog, psso) (see Stitch Guide), k2; rep from * to last st, k1.

ROW 9: Sl 1 pwise wyf, k2, *ssk, k5, k2tog, k2, yo, [k2tog, yo] 3 times, k1, yo, k2; rep from * to last 4 sts, k4.

ROW 11: Sl 1 pwise wyf, k2, *ssk, k3, k2tog, k2, yo, [k2tog, yo] 3 times, k3, yo, k2; rep from * to last 4 sts, k4.

ROW 13: Sl 1 pwise wyf, k2, *ssk, k1, k2tog, k2, yo, [k2tog, yo] 3 times, k2, MB, k2, yo, k2; rep from * to last 4 sts, k4.

ROW 15: Sl 1 pwise wyf, k2, *(sl 1, k2tog, psso), k2, yo, [k2tog, yo] 3 times, k2, MB, k1, MB, k2, yo, k2; rep from * to last 4 sts, k4.

ROW 16: Sl 1 pwise wyf, purl to last st, k1.

Rep Rows 1–16 for patt.

Instructions

Loosely CO 47 sts using long-tail cast-on (see Glossary) over two needles held together as one.

ROW 1: Purl.

ROW 2: Knit.

ROWS 3–194: Work Rows 1–16 of Angel Blossom patt (from Stitch Guide or chart) 12 times.

ROW 195: Purl.

ROW 196: Knit.

Loosely BO all sts, leaving a 10" to 12" (25.5 to 30.5 cm) tail, then cut yarn.

Finishing

With yarn tail threaded on a tapestry needle, use mattress st (see Glossary) to sew BO and CO edges for about 5" (12.5 cm).

TIE

With dpn, CO 3 sts. Work I-cord (see Glossary) until piece measures 55" to 60" (139.5 to 152.5 cm) long. BO sts. Lay cowl with RS facing and seam at top. Starting at seam, weave tie in and out using eyelet created on Row 8 of each patt rep. Tie an overhand knot in each end of the I-cord.

Block to measurements. Weave in loose ends.

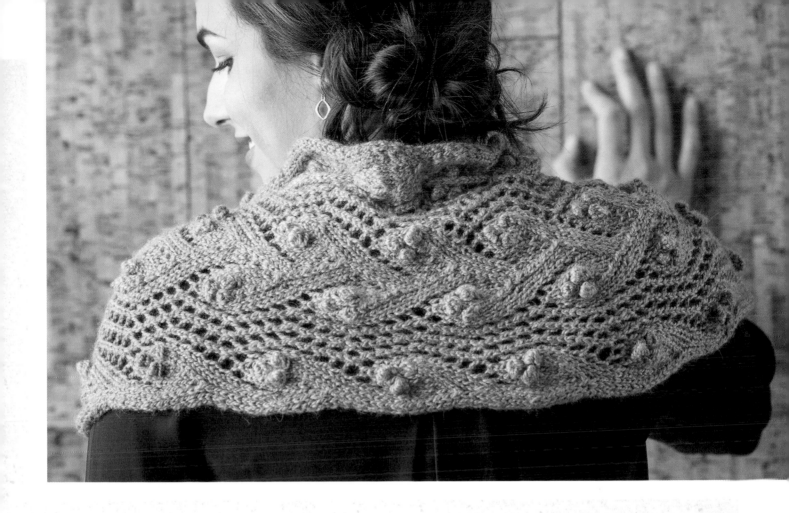

ANGEL BLOSSOM PATTERN

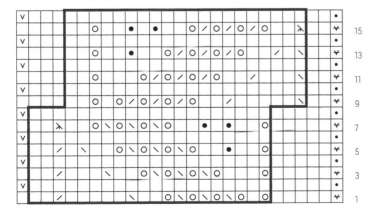

20-st repeat

	k on RS; p on WS
•	p on RS; k on WS
∕	k2tog
＼	ssk
⅄	sl 1, k2tog, psso
∨	sl 1 pwise wyf on WS
ⱽ	sl 1 pwise wyf on RS
●	MB (see Stitch Guide)
	pattern repeat

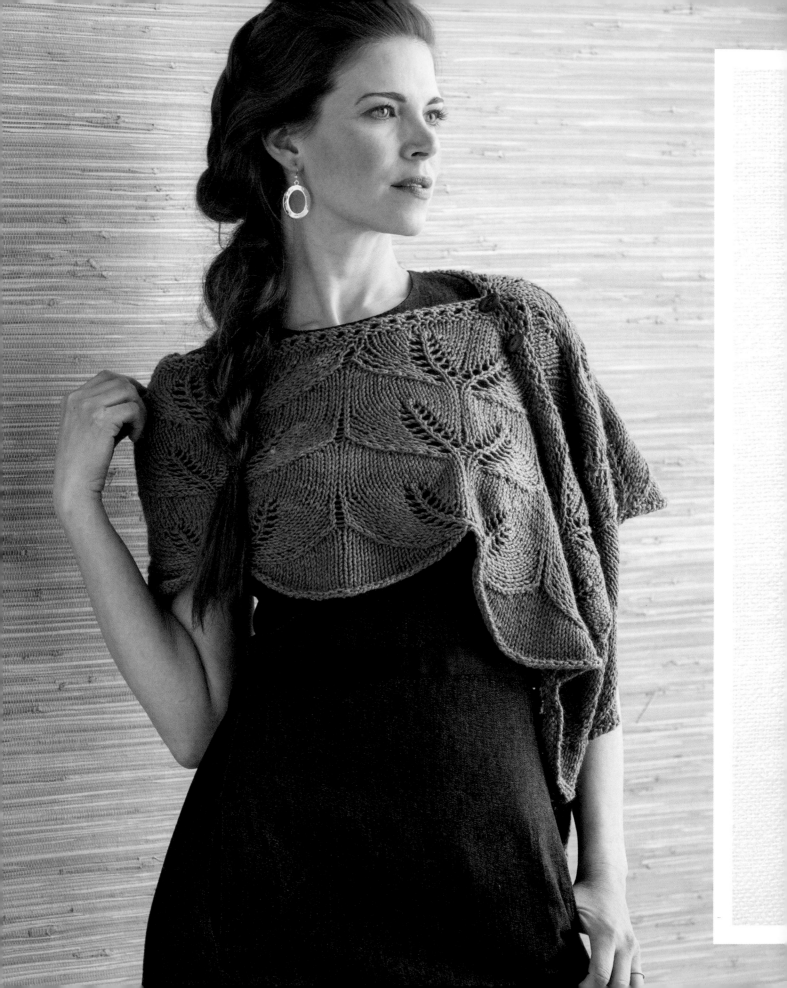

FINISHED SIZE
About 54 (59¾)" (137
[152] cm) wide across top
edge and 62 (79¾)" (157.5
[202.5] cm) wide across
bottom edge. About 11½
(14)" (29 [35.5] cm) long.

Piece shown measures
54" (137 cm) (scarf size).

YARN
Worsted weight
(#4 Medium).

Shown here: Cascade
220 Superwash (100%
superwash wool; 220 yd
[201 m]/100 g): #1919
Turtle, 2 (4) skeins.

NEEDLES
Size U.S. 7 (4.5 mm):
24" (61 cm) or longer
circular (cir).

Size U.S. 9 (5.5 mm):
24" (61 cm) or longer cir.

*Adjust needle sizes if
necessary to obtain the
correct gauge.*

NOTIONS
Markers (m); tapestry
needle; two ¾" (2 cm)
buttons; sewing needle
and matching thread.

GAUGE
39 sts and 20 rows of
Large Leaf patt from chart
= 9" (23 cm) wide and
3½" (9 cm) long on larger
needles.

Lotus

This leaf stitch piece has little eyelets and a pretty wavy edging to create a cute yet sophisticated garment. This design comes in two different sizes for a scarf or shawl. Because the border has eyelets that can be used as buttonholes, you can wear this piece as a cape instead of a scarf or shawl.

STITCH GUIDE

SL 1 PWISE WYF

Slip 1 st purlwise with yarn in front.

NOTES

— For selvedge stitches, slip the first stitch of every row as if to purl with yarn in front (pwise wyf) and knit the last stitch of every row as shown on the charts.

— Use markers to separate pattern repeats.

Instructions

With larger cir needle, CO 275 (353) sts. Knit 1 row.

Work Rows 1–20 of Large Leaf patt from chart, working the 39-st patt rep 7 (9) times—261 (335) sts.

Work Rows 1–18 of Medium Leaf patt from chart, working the 37-st patt rep 7 (9) times—233 (299) sts.

Work Rows 1–16 of Small Leaf patt from chart, working the 33-st patt rep 7 (9) times—205 (263) sts.

SCARF: Skip to Border.

SHAWL: Work Rows 1–14 of Extra-Small Leaf patt from chart, working the 29-st patt rep 9 times—227 sts.

BORDER

Change to smaller cir needle and work as follows:

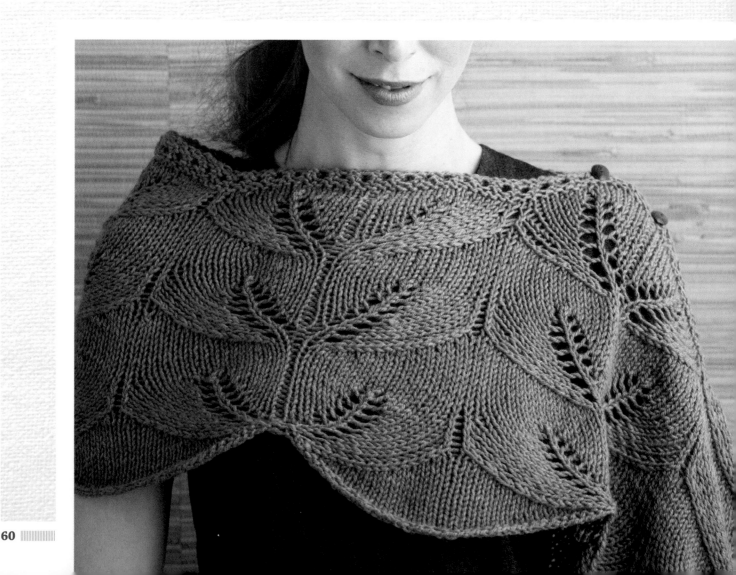

LARGE LEAF

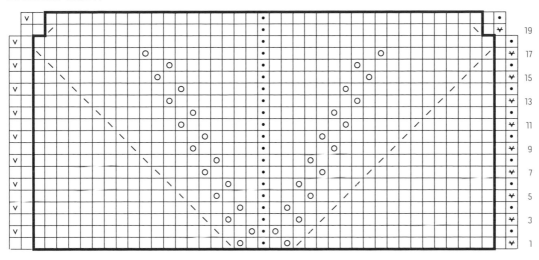

39-st repeat dec'd to 37-st repeat

MEDIUM LEAF

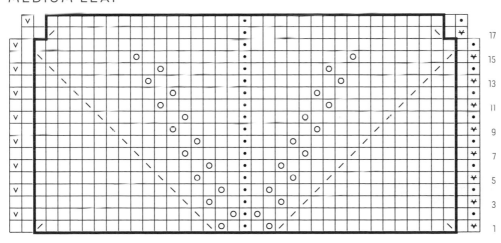

37-st repeat dec'd to 33-st repeat

	k on RS; p on WS		ssk on RS; p2tog tbl on WS
•	p on RS; k on WS	v	sl 1 pwise wyf on WS
o	yo	⊬	sl 1 pwise wyf on RS
/	k2tog on RS; p2tog on WS		pattern repeat

SMALL LEAF

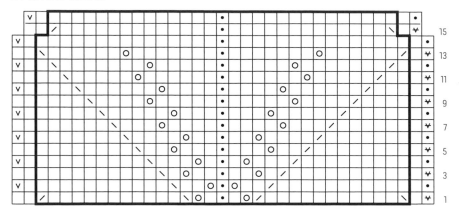

33-st repeat dec'd to 29-st repeat

EXTRA-SMALL LEAF

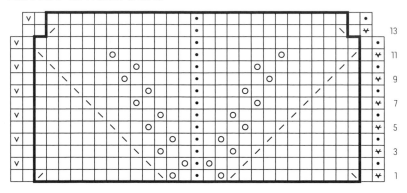

29-st repeat dec'd to 25-st repeat

□	k on RS; p on WS	
·	p on RS; k on WS	
O	yo	
/	k2tog on RS; p2tog on WS	

\	ssk on RS; p2tog tbl on WS	
V	sl 1 pwise wyf on WS	
⊻	sl 1 pwise wyf on RS	
◻	pattern repeat	

ROWS 1–4: Knit.

ROW 5: (RS) K1, *k2tog, yo; rep from * to last 2 sts, k2.

ROWS 6 AND 7: Knit.

BO all sts knitwise.

Finishing

Weave in loose ends. Block piece.

With RS facing and border on top, sew first button to border 13½ (16½)" (34.5 [42 cm]) from left selvedge and 2nd button 3" (7.5 cm) away from first button. Use any existing hole on the border as a buttonhole.

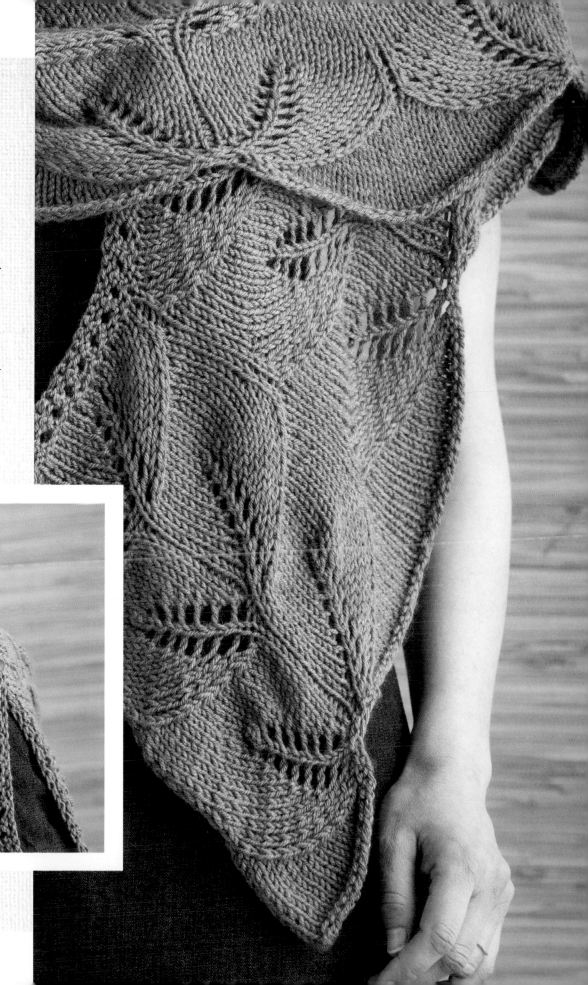

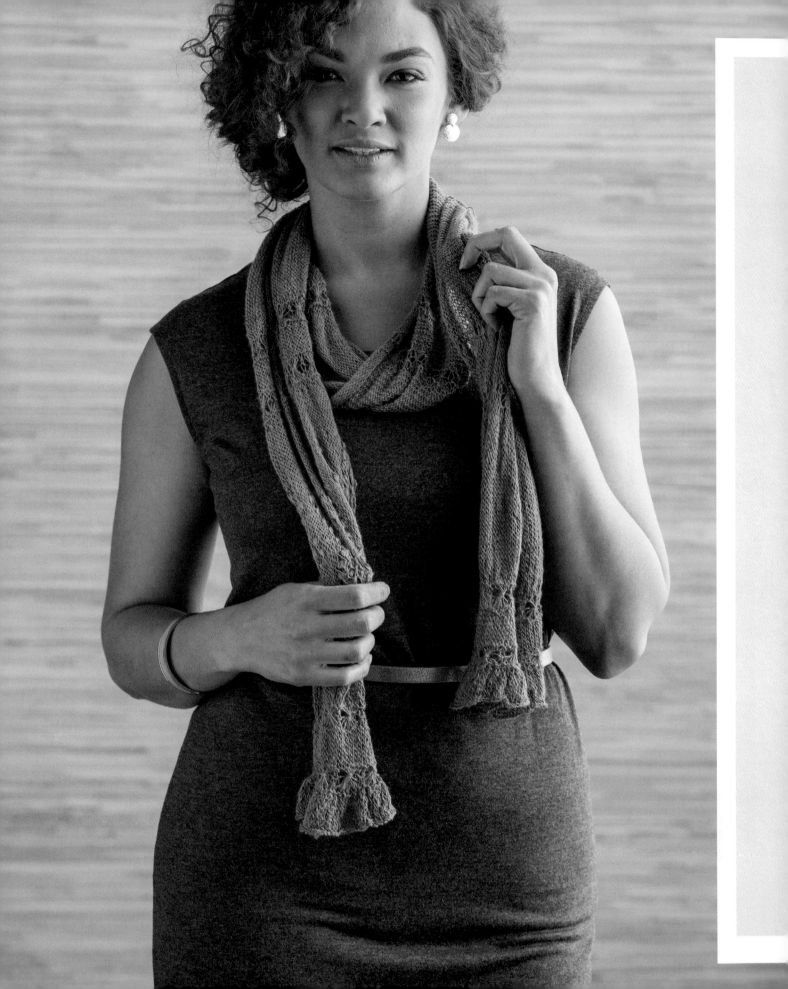

FINISHED SIZE
Width varies between 8½"
(21.5 cm) in Daisy Chain
sections and 11" (28 cm)
in St st sections.

About 71" (180 cm) long.

YARN
Laceweight (#0 Lace).

Shown here: Zitron
Traum Seide (100%
mulberry silk; 875 yd
[800 m]/100 g): #19
Jasper, 1 skein.

NEEDLES
Size U.S. 6 (4 mm).

*Adjust needle size if
necessary to obtain the
correct gauge.*

NOTIONS
Markers (m); tapestry
needle.

GAUGE
30 sts and 26 rows =
4" (10 cm) in St st after
blocking.

28 sts and 6 rows in Daisy
Chain patt = 4" (10 cm)
wide and 1⅛" (2.9 cm)
long.

Baby's Breath

I was looking for a lace border for this design when I found a swatch I had made using the daisy chain pattern. The swatch was worked in DK weight yarn, but I tried it with laceweight yarn, and the pattern showed completely differently because of the yarn weight. I loved it so much in the finer yarn that I decided to use it repeatedly throughout this scarf. I added a lace stitch with bobbles to one side of the scarf to add a little challenge and to show another pretty knitting pattern.

STITCH GUIDE

1-INTO-7 INC
Work ([k1, yo] 3 times, k1) all in the same st.

SL 1, K2TOG, PSSO
Sl 1 st as if to knit, k2tog, pass slipped stitch over previous st—2 sts dec'd.

STOCKINETTE ST WITHOUT SELVEDGE STITCHES
ROW 1: (RS) Knit.

ROW 2: (WS) Purl.

Rep Rows 1 and 2 for patt.

STOCKINETTE ST WITH SELVEDGE STITCHES
(St st with selvedge)

ROW 1: (RS) K1, p1, knit to last 2 sts, p1, k1.

ROW 2: (WS) P1, k1, purl to last 2 sts, k1, p1.

Rep Rows 1 and 2 for patt.

DAISY CHAIN PATTERN
(multiple of 6 sts + 5)

ROW 1: (RS) K1, p1, knit to last 2 sts, p1, k1.

ROW 2: P1, knit to last st, p1.

ROW 3: K1, p1, k1, *[insert needle into next st and wrap yarn around needle 3 times, then knit the st withdrawing all the wraps along with the needle] 5 times, k1; rep from * to last 2 sts, p1, k1.

ROW 4: P1, k2, *[sl 1 st with yarn in front dropping extra 2 wraps] 5 times, [bring yarn to back, sl 5 sts back to left needle, bring yarn to front, sl 5 sts to right needle] twice, k1; rep from * to last 2 sts, k1, p1.

ROWS 5 AND 6: Rep Rows 1 and 2.

Instructions

Loosely CO 118 sts.

FIRST BORDER
ROWS 1–9: Work in St st (without selvedge sts).

ROW 10: [P2tog] 59 times—59 sts.

DAISY CHAIN SECTION
ROWS 1–6: Work Rows 1–6 of Daisy Chain patt from Stitch Guide.

ROWS 7–12: Work in St st with selvedge.

ROWS 13–18: Work Rows 1–6 of Daisy Chain patt once.

LACE SECTION
ROW 1: (RS) K1, p1, knit to last 2 sts, p1, k1.

ROW 2: (Inc) P1, k1, M1P (see Glossary), [p2, M1P, p2, M1P, p1] 11 times, M1P, k1, p1—83 sts.

ROWS 3–12: Work in St st with selvedge.

ROWS 13–46: Work Rows 1–34 of Lace Panel from chart.

ROWS 47–57: Work in St st with selvedge.

ROW 58: (Dec) P1, k1, p2tog, [p2tog, p2, p2tog, p1] 10 times, p2tog, p1, [p2tog] twice, k1, p1—59 sts.

MAIN SECTION
ROWS 1–6: Work Rows 1–6 of Daisy Chain patt.

ROWS 7–12: Work in St st with selvedge.

ROWS 13–18: Work Rows 1–6 of Daisy Chain patt once.

ROW 19: K1, p1, knit to last 2 sts, p1, k1.

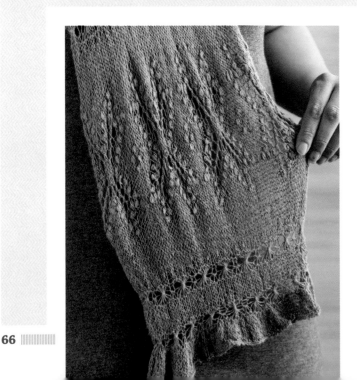

LACE PANEL

18-st repeat

Row numbers (right side, odd): 1, 3, 5, 7, 9, 11, 13, 15, 17, 19, 21, 23, 25, 27, 29, 31, 33

Legend:

- ☐ k on RS; p on WS
- · p on RS; k on WS
- ○ yo
- ╱ k2tog
- ╲ ssk
- ⋏ sl 1, k2tog, psso
- ⇡ p7tog
- ⇣ 1-into-7 inc (see Stitch Guide)
- ☐ pattern repeat

ROW 20: (Inc) P1, k1, M1P, [p2, M1P, p2, M1P, p1] 11 times, M1P, k1, p1—83 sts.

ROWS 21–53: Work in St st with selvedge.

ROW 54: (Dec) P1, k1, p2tog, [p2tog, p2, p2tog, p1] 10 times, p2tog, p1, [p2tog] twice, k1, p1—59 sts.

Rep Rows 1–54 five more times, then rep Rows 1–18 once more.

SECOND BORDER

ROW 1: (RS) Knit.

ROW 2: (Inc) P1f&b (see Glossary), [M1P, p1] 58 times—118 sts.

ROWS 3–10: Work in St st (without selvedge sts).

Loosely BO all sts.

Finishing

Block scarf. Weave in loose ends.

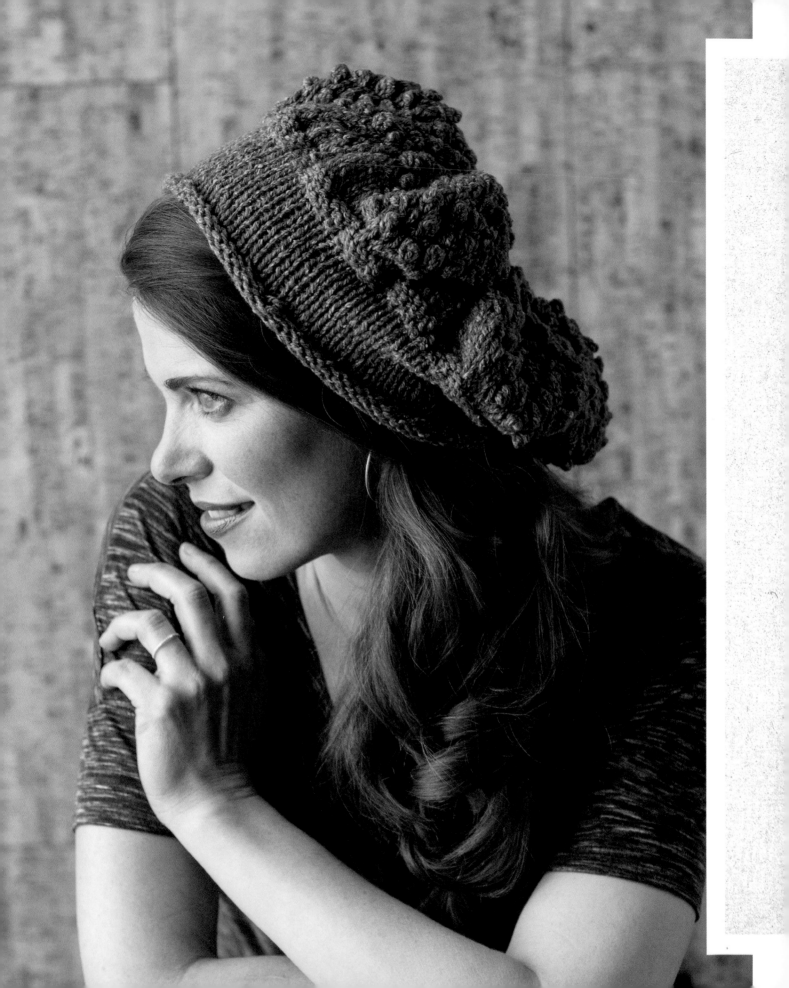

FINISHED SIZE

20½" (52 cm) circumference at brim and 9½" (24 cm) tall.

YARN

Worsted weight (#4 Medium).

Shown here: Elsebeth Lavold Silky Wool XL (80% wool, 20% silk; 104 yd [95 m]/50 g): #009 Dark Turquoise, 2 balls.

NEEDLES

Size U.S. 9 (5.5 mm): 16" (40.5 cm) circular (cir).

Size U.S. 10 (6 mm): 16" (40.5 cm) cir and double-pointed (dpn).

Adjust needle sizes if necessary to obtain the correct gauge.

NOTIONS

Markers (m); tapestry needle.

GAUGE

16 sts and 23 rnds = 4" (10 cm) in St st on smaller needle.

Hydrangea

The top of this hat is full of flower petals. I fell in love with this bobble flower motif as soon as I found it in *150 Knit and Crochet Motifs* by Heather Lodinsky (Interweave, 2011). I love these kinds of motifs that look like they were crocheted. This hat has a bubbly, bumpy, wavy texture that is unusual in knitting and is made by knitting a version of the bobble flower motif and then simply knitting on a brim.

STITCH GUIDE

SL 1 WYF
Slip 1 st purlwise with yarn in front.

MAKE BOBBLE (MB)
Work (k1, p1, k1) all in next st—3 sts made from 1 st. Turn work, p3 with WS facing, turn work, k3tog tbl with RS facing—3 sts dec'd to 1 st again.

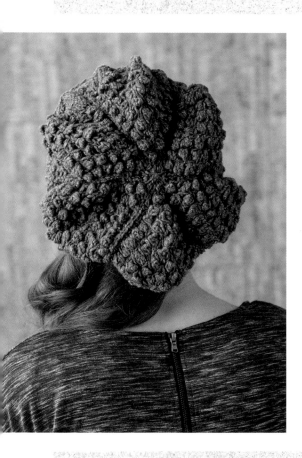

Instructions

NOTE: The hat is worked from the top of the crown to the brim in 6 identical sections. Use markers to separate pattern repeats.

CROWN
With dpn, CO 6 sts. Place marker (pm) for beg of rnd and join for working in the rnd, being careful not to twist sts.

NOTE: Change to cir needle when there are enough sts to work comfortably.

Work Rnds 1–34 of Crown chart or as follows:

RND 1: [K1f&b] 6 times—12 sts.

RND 2: Knit.

RND 3: [K1f&b, k1] 6 times—18 sts.

RND 4: [MB (see Stitch Guide), k2] 6 times.

RND 5: [K1, k1f&b, k1] 6 times—24 sts.

RND 6: [K1, M1 (see Glossary), sl 1 wyf (see Stitch Guide), k1, sl 1 wyf, M1] 6 times—36 sts.

RND 7: [K1, MB, k3, MB] 6 times. There are 2 bobbles per section.

RND 8: [K2, M1, sl 1 wyf, k1, sl 1 wyf, M1, k1] 6 times—48 sts.

RND 9: [MB, k1, MB, k3, MB, k1] 6 times—3 bobbles per section.

RND 10: [K3, M1, sl 1 wyf, k1, sl 1 wyf, M1, k2] 6 times—60 sts.

RND 11: [(K1, MB) 2 times, k3, MB, k1, MB] 6 times—4 bobbles per section.

RND 12: [K4, M1, sl 1 wyf, K1, sl 1 wyf, M1, k3] 6 times—72 sts.

RND 13: [(MB, k1) 2 times, MB, k3, (MB, k1) 2 times] 6 times—5 bobbles per section.

RND 14: [K5, M1, sl 1 wyf, k1, sl 1 wyf, M1, k4] 6 times—84 sts.

RND 15: [(K1, MB) 3 times, k3, (MB, k1) 2 times, MB] 6 times—6 bobbles per section.

RND 16: [K6, M1, sl 1 wyf, k1, sl 1 wyf, M1, k5] 6 times—96 sts.

RND 17: [(MB, k1) 3 times, MB, k3, (MB, k1) 3 times] 6 times—7 bobbles per section.

RND 18: [K7, M1, sl 1 wyf, k1, sl 1 wyf, M1, k6] 6 times—108 sts.

RND 19: [(K1, MB) 4 times, k3, (MB, k1) 3 times, MB] 6 times—8 bobbles per section.

RND 20: [K8, M1, sl 1 wyf, k1, sl 1 wyf, M1, k7] 6 times—120 sts.

RND 21: [(MB, k1) 3 times, MB, k7, (MB, k1) 3 times] 6 times—7 bobbles per section.

RND 22: [K9, M1, sl 1 wyf, k1, sl 1 wyf, M1, k8] 6 times—132 sts.

RND 23: [(K1, MB) 3 times, K11, (MB, K1) 2 times, MB] 6 times—6 bobbles per section.

RND 24: [K10, M1, sl 1 wyf, k1, sl 1 wyf, M1, k9] 6 times—144 sts.

RND 25: [(MB, k1) 2 times, MB, k15, (MB, k1) 2 times] 6 times—5 bobbles per section.

RND 26: [K11, M1, sl 1 wyf, k1, sl 1 wyf, M1, k10] 6 times—156 sts.

RND 27: [(K1, MB) 2 times, k19,

MB, k1, MB] 6 times—4 bobbles per section.

RND 28: [K12, M1, sl 1 wyf, k1, sl 1 wyf, M1, k11] 6 times—168 sts.

RND 29: Knit.

RND 30: [K13, M1, sl 1 wyf, k1, sl 1 wyf, M1, k12] 6 times—180 sts.

RND 31: Knit.

RNDS 32–34: Purl.

BRIM

Change to smaller cir needle.

RND 1: K2tog, k3tog, [k2tog 2 times, k3tog] 25 times—77 sts.

RND 2: Knit.

Rep Rnd 2 nineteen more times or until brim measures 3½" (9 cm). BO all sts.

Finishing

Weave in loose ends.
Block piece if desired.

CROWN

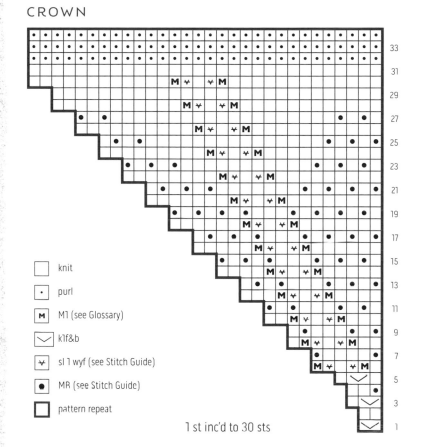

1 st inc'd to 30 sts

☐ knit

· purl

M M1 (see Glossary)

⌣ k1f&b

✛ sl 1 wyf (see Stitch Guide)

● MR (see Stitch Guide)

☐ pattern repeat

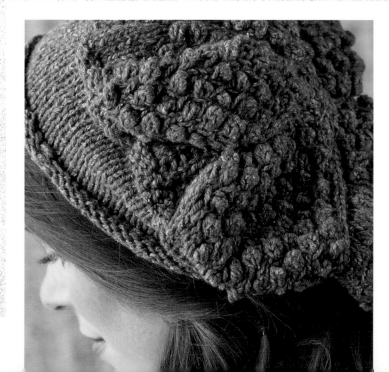

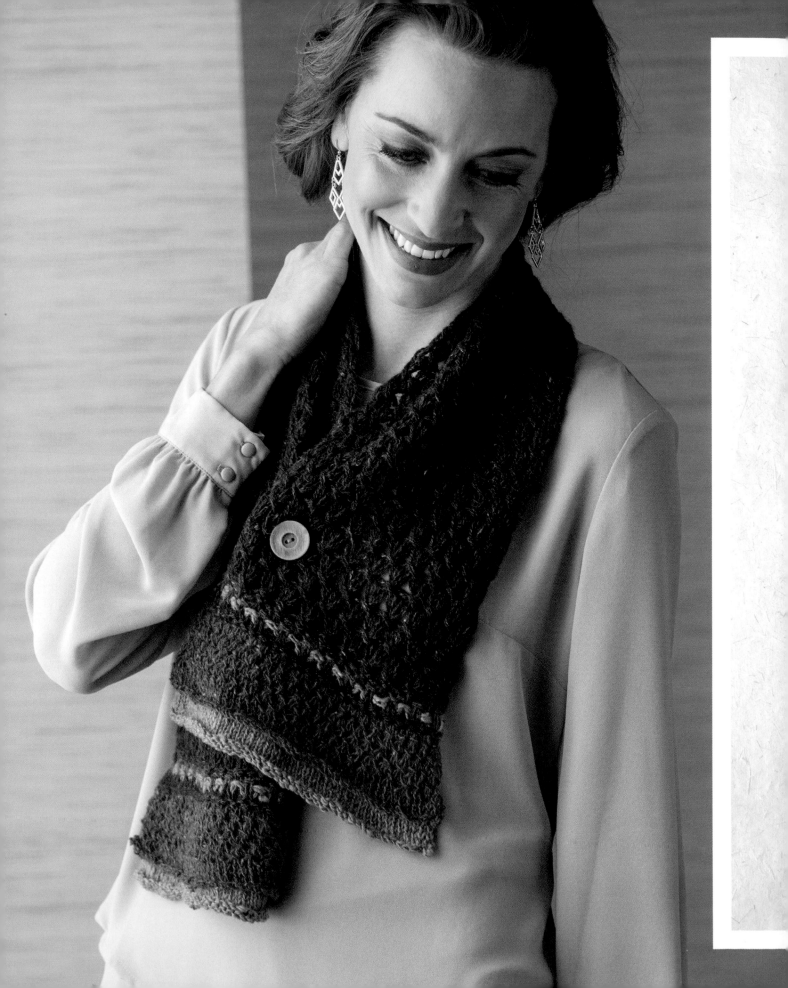

FINISHED SIZE
41" (104 cm) long
including ruffles and 7¼"
(18.5 cm) wide.

YARN
DK weight (#3 Light)
and fingering weight
(#1 Super Fine).

Shown here: Rowan
Felted Tweed DK (50%
merino wool, 25% alpaca,
25% viscose; 191 yd
[175 m]/50 g): #151
Bilberry (A), 2 balls.
Rowan Fine Tweed (100%
wool; 98 yd [90 m]/25 g):
#373 Dent (orange; B)
and #378 Litton (gray; C),
1 ball each.

NEEDLES
Sizes U.S. 13 (9 mm) and
U.S. 7 (4.5 mm)

*Adjust needle sizes if
necessary to obtain the
correct gauge.*

NOTIONS
Smooth waste yarn for
provisional cast-on;
tapestry needle; one 1⅛"
(2.9 cm) button; sewing
needle and matching
thread.

GAUGE
12 sts and 10 rows = 4"
(10 cm) in Lace patt with
DK weight yarn held
double on larger needles
after blocking.

Allium

The same lace pattern is used in the main part of the scarf and the front ruffles, but in different yarn weights. This scarf can easily be changed to fit your style. Using a self-striping yarn may be fun (if you choose this option, I recommend using chunky-weight yarn instead of two strands of DK weight to preserve the color repeats). Or you could attach two or three buttons in contrasting colors, make a longer scarf without buttons, or work longer ruffles—the choice is yours.

STITCH GUIDE

SL 1 PWISE WYF
Slip 1 st purlwise with yarn in front.

SL 1 PWISE WYB
Slip 1 st purlwise with yarn in back.

LACE PATTERN (odd number of sts; number of sts does not remain constant).
ROW 1: (RS) K1, *yo, sl 1 pwise wyb, k1, yo, pass slipped stitch over (psso) previous 2 sts; rep from * to end.

ROW 2: *P2, drop yo from preceding row; rep from * to last st, p1.

ROW 3: K2, *yo, sl 1 pwise wyb, k1, yo, psso previous 2 sts; rep from * to last st, k1.

ROW 4: P3, *drop yo of preceding row, p2; rep from * to end.

Rep Rows 1–4 for patt.

PICK UP AND KNIT ALONG BO EDGE
When picking up and knitting stitches along BO edge for the ruffles, insert tip of needle into front or back loop (as directed) of stitch in BO chain and not into the center of the stitch below the BO edge.

Instructions

NOTE: This scarf is knitted with 2 strands of yarn held together except when working the 2 ruffles. If knitting from a center-pull ball, 1 strand can come from the center and the other from the outside.

MAIN SECTION
With smooth waste yarn and using a provisional method (see Glossary), CO 25 sts with larger needles. Change to 2 strands of A held tog.

ROW 1: (WS) Knit.

ROWS 2–85: Work Rows 1–4 of Lace patt (see Stitch Guide) 21 times.

ROWS 86 AND 87: Knit.

END OF SCARF
ROW 1: (RS) With 2 strands of B held tog, k2, *sl 1 pwise wyb, k1; rep from * to last st, k1.

ROW 2: K2, *sl 1 pwise wyf, k1; rep from * to last st, k1.

ROW 3: With 2 strands of C held tog, k1, *sl 1 pwise wyb, k1; rep from * to end.

ROW 4: K1, *sl 1 pwise wyf, k1; rep from * to end.

ROW 5: With 2 strands of A held tog, knit.

Loosely BO all sts knitwise (kwise).

Carefully remove waste yarn from provisional CO and place 25 exposed sts on needle. Work Rows 1–5 above for other end of scarf and loosely BO all sts kwise.

RUFFLE EDGING
Larger Back Ruffle
Lay scarf down with RS facing and BO edge at the top. With single strand of C and smaller needles, work as follows:

ROW 1: (RS) Pick up and knit the first back loop of BO chain, *yo,

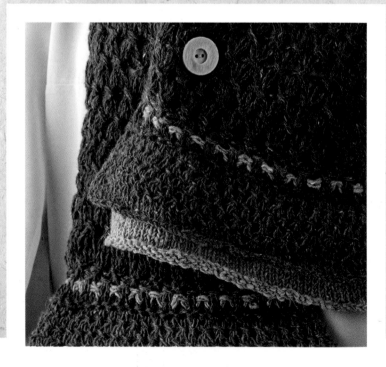

pick up and knit the next back loop of BO chain; rep from * to end—49 sts.

ROW 2: P1, *p1tbl, p1; rep from * to end.

ROW 3: Knit.

ROW 4: Purl.

ROWS 5–26: Rep Rows 3 and 4.

Loosely BO all sts.

Lacy Front Ruffle

Lay scarf down with RS facing up and BO edge at the top. With single strand of B and smaller needles, work as follows:

ROW 1: (RS) Pick up and knit the first front loop of BO chain, *yo, pick up and knit the next front loop of BO chain; rep from * to end—49 sts.

ROW 2: P1, *p1tbl, p1; rep from * to end.

ROWS 3–10: Work Rows 1–4 of Lace patt twice.

ROW 11: Knit.

ROW 12: Purl.

Rep Rows 11 and 12.

Loosely BO all sts.

Rep Ruffle Edging section for other end of scarf.

Finishing

Weave in loose ends. Block scarf to measurements.

Sew button at center of scarf about 12" (30.5 cm) from end of larger back ruffle.

Use any existing hole in the scarf as a buttonhole.

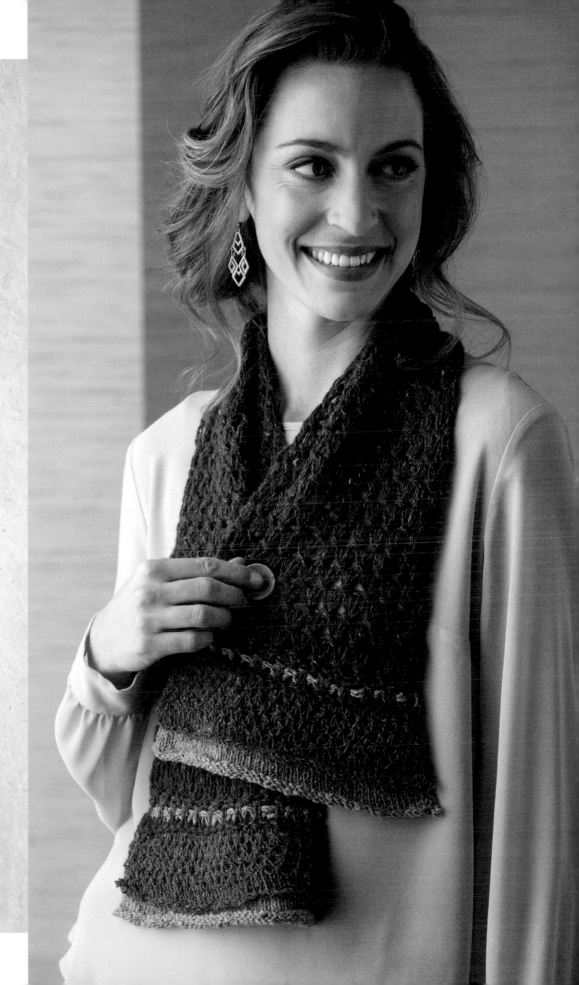

FINISHED SIZE
18½" (47 cm) head circumference at brim and 11" (28 cm) tall.

YARN
Sportweight (#2 Fine).

Shown here: Zitron Lifestyle (100% merino wool; 170 yd [155 m]/50 g): #95 Olive, 2 balls.

NEEDLES
Size U.S. 4 (3.5 mm): 16" (40.5 cm) circular (cir).

Size U.S. 7 (4.5 mm): 16" (40.5 cm) cir and double-pointed (dpn).

Adjust needle sizes if necessary to obtain the correct gauge.

NOTIONS
Markers (m); tapestry needle.

GAUGE
20 sts and 28 rnds = 4" (10 cm) in St st on larger needle after blocking.

Clematis

This hat is simple yet stylish with a slipped-stitch texture as well as a textured flower shape on one side of the hat. Most of the hat is worked in knit rounds and narrow purl rounds, with slipped stitches added on some knit rounds to create seven rounded blocks shaped like petals. The gauge for this project is deliberately worked slightly looser than normal for sportweight yarn to create softly draping fabric and a slouchy-looking hat.

STITCH GUIDE

SL 2 WYB
Slip 2 sts purlwise with yarn in back.

TWISTED RIB
(even number of sts)

RND 1: *K1tbl, p1; rep from * to end.

Rep Rnd 1 for patt.

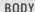

Instructions

BRIM
With smaller cir needle, CO 112 sts. Place marker (pm) and join for working in the rnd, being careful not to twist sts.

RNDS 1–8: Knit.

RNDS 9–16: Work in twisted rib (see Stitch Guide).

Change to larger cir needle.

RNDS 17–23: Knit.

BODY

RNDS 1 AND 2: Purl.

RNDS 3–8: K5, [sl 2 wyb, k6] 2 times, sl 2 wyb, knit to end.

RNDS 9 AND 10: Purl.

RNDS 11–16: K1, [sl 2 wyb, k6] 3 times, sl 2 wyb, knit to end.

RNDS 17 AND 18: Purl.

RNDS 19–24: K5, [sl 2 wyb, k6] 2 times, sl 2 wyb, knit to end.

RNDS 25 AND 26: Purl.

RNDS 27–32: Knit.

Rep Rnds 25–32 three more times, then work Rnds 25 and 26 once more.

SHAPE CROWN

RND 1: K14, [pm, k14] 7 times—112 sts.

RND 2: [Knit to 2 sts before m, k2tog] 8 times—104 sts.

RND 3: Knit.

Rep Rnds 1 and 2 eight more times changing to dpn when necessary—40 sts.

Finishing

Cut yarn leaving a 6" to 8" (15 to 20.5 cm) tail. Thread tail onto a tapestry needle, run needle through sts, and pull tight to close top of hat.
Weave in loose ends. Block to measurements.

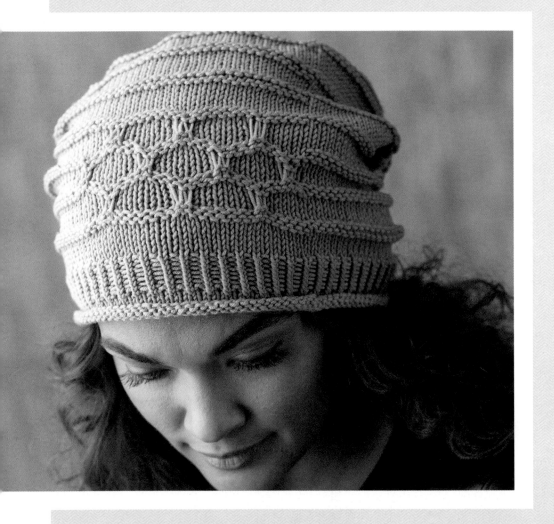

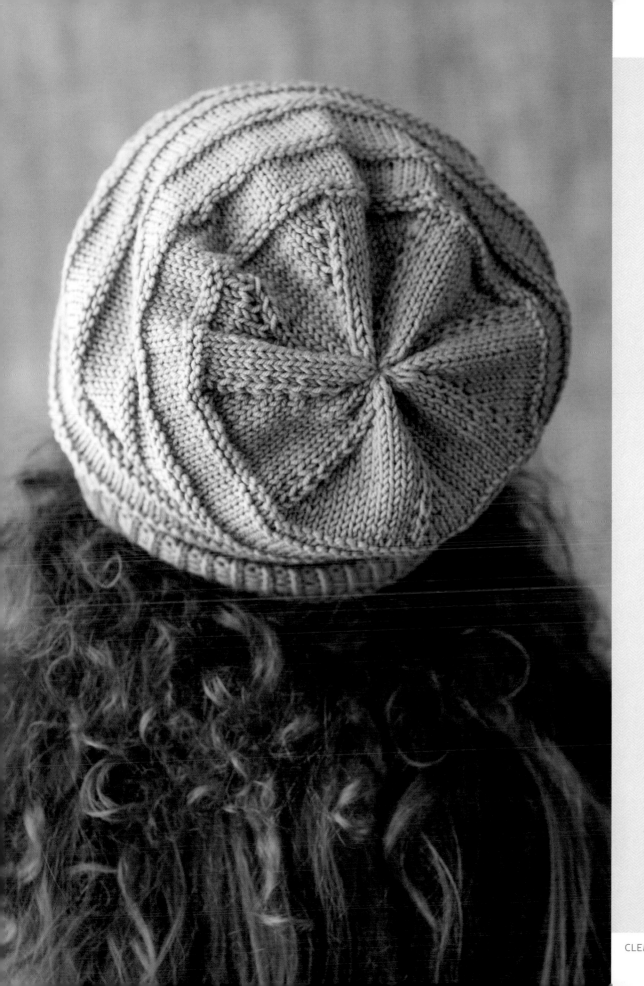

FINISHED SIZE
About 6" (15 cm) at the
widest point and 48¾"
(124 cm) long.

About 22" (56 cm) head
circumference when tied.

YARN
Sportweight (#2 Fine).

Shown here: Zitron Yarn
Kimono (54% merino
wool, 46% mulberry silk;
328 yd [300 m]/100 g):
#4014 Slate Blue,
1 skein.

NEEDLES
Sizes U.S. 7 (4.5 mm)
and U.S. 10 (6 mm).

*Adjust needle sizes if
necessary to obtain the
correct gauge.*

NOTIONS
Removable markers (m);
tapestry needle.

GAUGE
20½ sts and 21 rows = 4"
(10 cm) in Mock Rib patt
on larger needles after
blocking.

19 sts and 26 rows = 4"
(10 cm) in Lace patt on
smaller needles after
blocking.

Bachelor Button

I don't usually wear a hat, but I
wear a headband quite often. It
is a nice accent that's easy to put
on when I'm hurrying to leave
the house in the morning. On this
headband, the center is worked in
a one-row repeat pattern that is
simple but has a nice rib texture.
The ties are worked in a lace
pattern, so they contrast nicely with
the stitch pattern from the center.

STITCH GUIDE

NOTE: Knit the first st of each row tightly, so the edges stay even.

LACE PATTERN

(multiple of 2 sts + 1)

ROW 1: (RS) *Ssk, yo; rep from * to last st, k1.

ROW 2: Purl.

ROW 3: K1, *yo, k2tog; rep from *.

ROW 4: Purl.

Rep Rows 1–4 for patt.

K1, P1 RIB

(odd number of sts)

ROW 1: (RS) K1, *p1, k1; rep from *.

ROW 2: P1, *k1, p1; rep from *.

Rep Rows 1 and 2 for patt.

MOCK RIB

(multiple of 4 sts + 3)

ROW 1: *K2, p2; rep from * to last 3 sts, k3.

Rep Row 1 for patt.

Instructions

INCREASE TO TAPER

With smaller needles, CO 4 sts.

ROW 1: Purl.

ROW 2: [K1f&b (see Glossary)] 4 times—8 sts.

ROW 3: Purl.

ROW 4: K1, [yo, k1] 7 times—15 sts.

ROW 5: Purl.

ROWS 6–105: Work Rows 1–4 of Lace patt (see Stitch Guide) 25 times or until piece measures 15" (38 cm) from CO, ending with a WS row.

ROWS 106–115: Work Rows 1 and 2 of k1, p1 rib (see Stitch Guide) 5 times.

NEXT ROW: (RS) Work (k1, p1, k1) all in the same st, [k1f&b] 14 times—31 sts.

Place marker (pm) to mark RS of fabric and end of first tie.

CENTER

Change to larger needles.

Work Row 1 of Mock Rib patt (see Stitch Guide) a total of 101 times or until piece measures 15"

to 15½" (38 to 39.5 cm) from marker, ending with a WS row. (Length will be longer after blocking.) Remove marker.

DECREASE TO TAPER

Change to smaller needles.

ROW 1: (RS) K3tog, [k2tog] 14 times—15 sts.

ROW 2: Purl.

ROWS 3–12: Work Rows 1 and 2 of k1, p1 rib a total of 5 times.

ROWS 13–92: Work Rows 1–4 of Lace patt 20 times or until piece measures 10¼" (26 cm) from beg of Lace patt, ending with a WS row.

ROW 93: [Ssk] 7 times, k1— 8 sts.

ROW 94: Purl.

ROW 95: [Ssk] 4 times—4 sts.

ROW 96: Purl.

BO all sts.

Finishing

Block piece. Weave in loose ends.

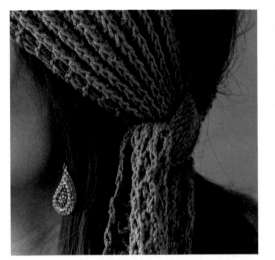

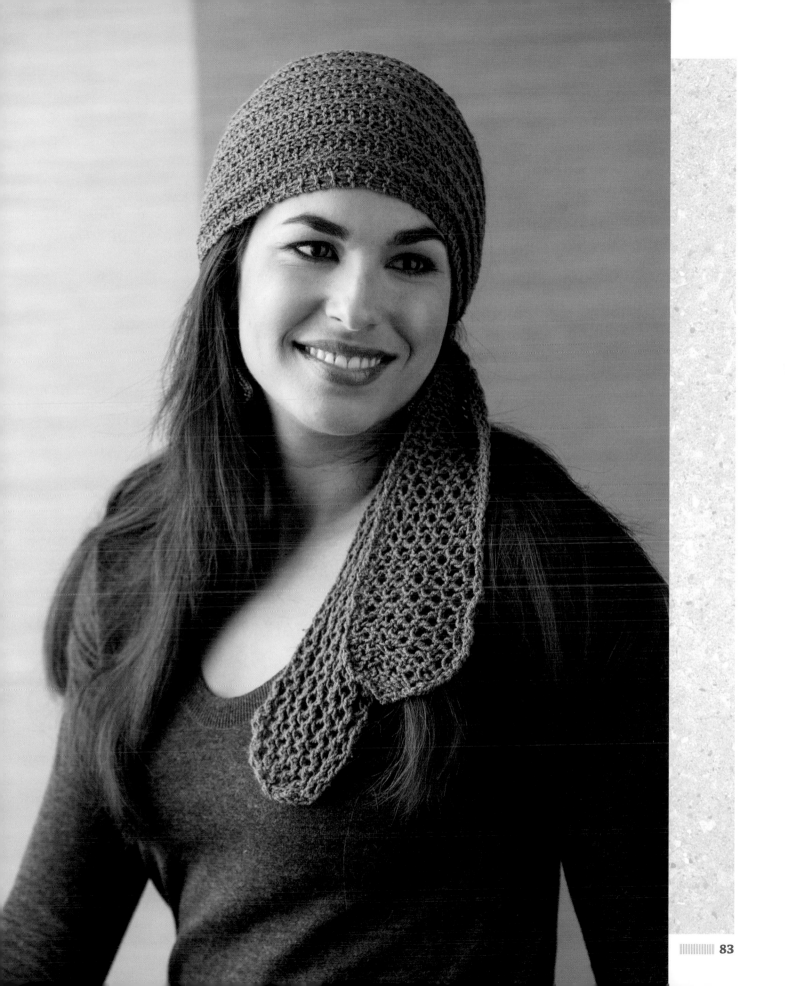

FINISHED SIZE

7⅛" (18 cm) hand circumference and 10" (25.5 cm) long.

YARN

Worsted weight (#4 Medium).

Shown here: Cascade 220 Superwash (100% superwash wool; 220 yd [200 m]/100 g): #1948 Mystic Purple, 1 ball.

NEEDLES

Size U.S. 6 (4 mm): set of 4 double-pointed (dpn).

Adjust needle size if necessary to obtain the correct gauge.

NOTIONS

Cable needle (cn); markers (m); stitch holder or waste yarn; tapestry needle.

GAUGE

22 sts and 28 rnds = 4" (10 cm) in St st.

30 sts and 31 rnds = 4" (10 cm) in cuff cable patt.

Grapevine

I like the look of cables with a smooth stockinette-stitch background. It creates a wavy, floating look like the surface of water and is very attractive. The cables create a wavy edging, so this effect is used on the top and bottom of these fingerless mitts for a beautiful yet unfinished look.

STITCH GUIDE

5/5 RC
Sl 5 sts onto cable needle (cn) and hold in back, k5, then k5 from cn.

5/5 LC
Sl 5 sts onto cn and hold in front of work, k5, then k5 from cn.

NOTES

— Binding off stitches loosely will let the edges curl.

— Both mitts are worked the same and can be worn on either hand.

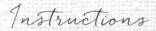

Instructions

CUFF

With 3 dpn, CO 54 sts (18 sts on each needle). Place marker (pm) for beg of rnd and join for working in the rnd, being careful not to twist sts.

RNDS 1–4: Knit.

RND 5: [K8, 5/5 LC (see Stitch Guide)] 3 times.

RNDS 6–12: Knit.

RNDS 13–20: Rep Rnds 5–12.

RND 21: Rep Rnd 5.

RNDS 22–30: Knit.

RND 31: [5/5 RC (see Stitch Guide), k8] 3 times.

RNDS 32–38: Knit.

RNDS 39–46: Rep Rnds 31–38.

RND 47: Rep Rnd 31.

THUMB GUSSET

RND 1: K3, M1 (see Glossary), k2, M1, k49—56 sts.

RND 2: Knit.

RND 3: K3, M1, k4, M1, k49—58 sts.

RND 4: Knit.

RND 5: K3, M1, k6, M1, k49—60 sts.

RND 6: Knit.

RND 7: K3, M1, k8, M1, k49—62 sts.

RND 8: Knit.

RND 9: K3, place 10 thumb sts on stitch holder or waste yarn, use

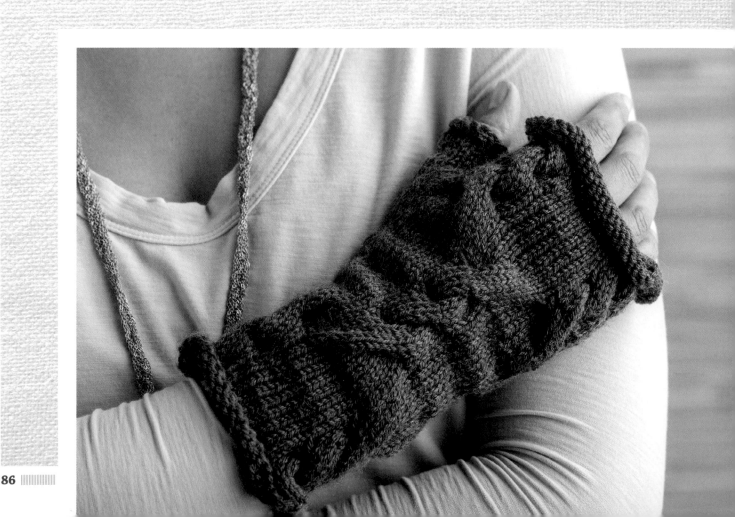

the knitted cast-on method to CO 2 sts, k3, 5/5 LC, [k8, 5/5 LC] 2 times—54 sts.

RNDS 10–16: Knit.

RND 17: [K8, 5/5 LC] 3 times.

RND 18–25: Rep Rnds 10–17.

RNDS 26–29: Knit.

Loosely BO all sts.

THUMB

Place 10 held thumb sts on needles. Join yarn to beg of sts with RS facing.

NEXT RND: K10, pick up and knit 2 sts from fabric between held sts and CO, pick up and knit 2 sts from base of sts CO over thumb gap, pick up and knit 2 sts from fabric between held sts and CO to close gap—16 sts. Arrange sts so that there are 5 sts each on Needle 1 and Needle 2 and 6 sts on Needle 3.

RNDS 1–3: Knit.

RND 4: K2, hold Needle 1 in back, k3 from Needle 2, k3 from Needle 1, k2 from Needle 2, k6 from Needle 3.

RNDS 5–8: Knit.

Loosely BO all sts.

Rep instructions to make 2nd mitt.

Finishing

Weave in loose ends. Block if desired.

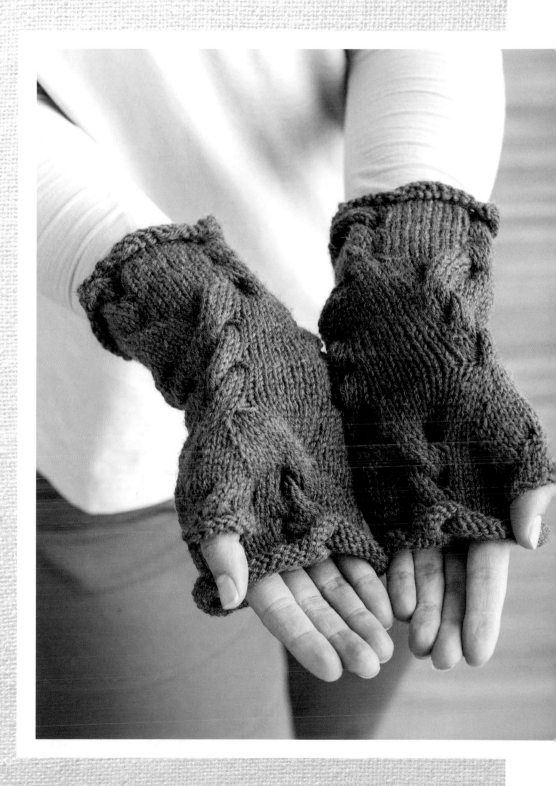

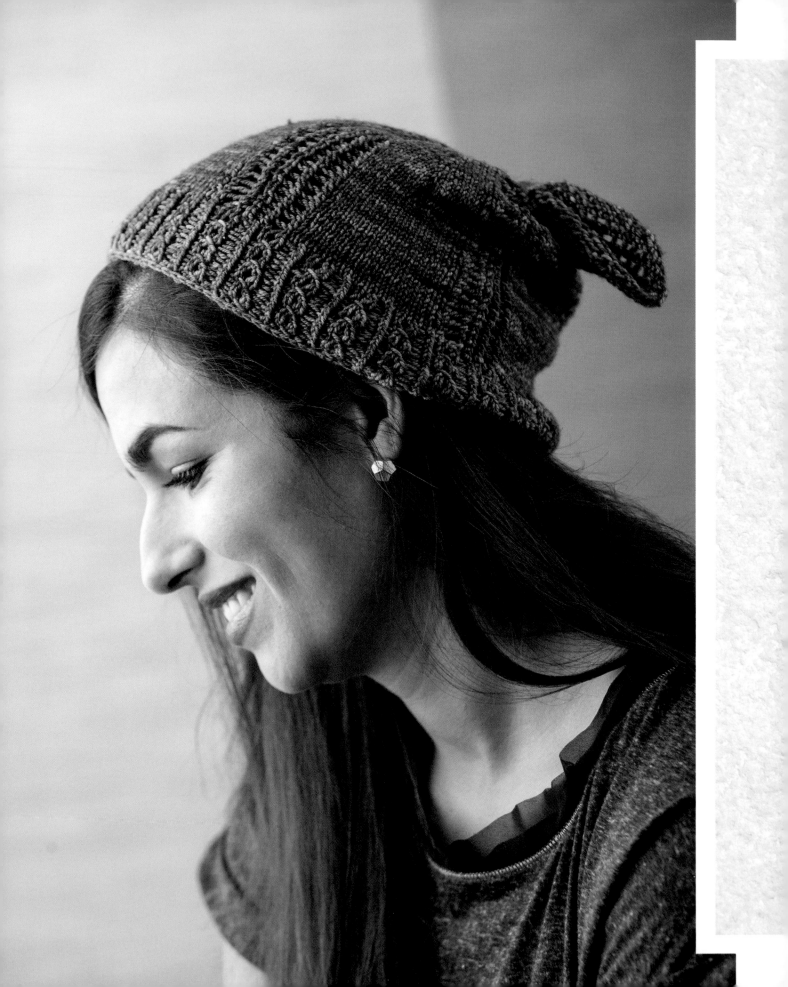

FINISHED SIZE
21½" (54.5 cm) head
circumference at brim
and 7¾" (19.5 cm) tall.

YARN
Fingering weight
(#1 Super Fine).

Shown here: Malabrigo
Sock (100% superwash
merino wool; 440 yd
[402 m]/100 g): #850
Archangel, 1 skein.

NEEDLES
Size U.S. 5 (3.75 mm):
set of double-pointed
(dpn) and 16" (40.5 cm)
circular (cir).

*Adjust needle size if
necessary to obtain the
correct gauge.*

NOTIONS
Markers (m); tapestry
needle.

GAUGE
28 sts and 40 rnds = 4"
(10 cm) in St st.

Lamb's Ear

This hat has three different eyelet patterns. The ties on top have eyelets all over, the crown has little eyelets within the simple lace pattern, and the brim has eyelets in the rib-stitch pattern. Enjoy working different patterns in each section! The lacy patterns worked in fingering-weight yarn produce a hat that is good year-round. The ties at the top are worked flat and joined for working in the round, and the rest of the hat is knitted from the top of the crown down to the brim.

STITCH GUIDE

SL 2, K1, P2SSO
Sl 2 sts as if to k2tog, k1, pass 2 slipped sts over—2 sts dec'd.

K1, P1 RIB
(odd number of sts)

ROW 1: (RS) K1, *p1, k1; rep from *.

ROW 2: (WS) P1, *k1, p1; rep from *.

Rep Rows 1 and 2 for patt.

Instructions

TIES
With 2 dpn, CO 25 sts.

ROW 1: (RS) K11, sl 2, k1, p2sso (see Stitch Guide), k11.

ROW 2: K1, [yo, ssk] 5 times, yo, p1, yo, [k2tog, yo] 5 times, k1.

ROWS 3–24: Rep Rows 1 and 2 five more times.

ROWS 25–44: Work in k1, p1 rib (see Stitch Guide).

Leaving a 4" to 5" [10 to 12.5 cm] tail, cut yarn and leave all sts on 1 dpn.

Make a 2nd tie but do not cut yarn.

CROWN TOP
With RS of both ties facing, knit 20 sts from tie with working yarn (needle 1), knit rem sts from tie with working yarn and 15 sts from other tie (needle 2), and knit rem sts from 2nd tie (needle 3)—50 sts total. Place marker (pm) and join for working in the rnd.

NEXT RND: Knit.

CROWN SHAPING
NOTE: Change to cir needle when there are enough sts to work comfortably.

RND 1: *[K2tog, yo] 2 times, k1, [yo, ssk] 2 times, k1; rep from * to end.

RND 2 AND ALL EVEN-NUMBERED RNDS: Knit.

RND 3: Rep Rnd 1.

RND 5: *[K2tog, yo] 2 times, k1, [yo,ssk] 2 times, M1 (see Glossary), k1, M1; rep from *—60 sts.

RND 7: *[K2tog, yo] 2 times, k1, [yo, ssk] 2 times, k3; rep from *.

RND 9: *[K2tog, yo] 2 times, k1, [yo, ssk] 2 times, [k1, M1] 2 times, k1; rep from *—70 sts.

RND 11: *[K2tog, yo] 2 times, k1, [yo, ssk] 2 times, k5; rep from *.

RND 13: *[K2tog, yo] 2 times, k1, [yo, ssk] 2 times, k2, M1, k1, M1, k2; rep from *—80 sts.

RND 15: *[K2tog, yo] 2 times, k1, [yo, ssk] 2 times, k7; rep from *.

RND 17: *[K2tog, yo] 2 times, k1, [yo, ssk] 2 times, k3, M1, k1, M1, k3; rep from *—90 sts.

RND 19: *[K2tog, yo] 2 times, k1, [yo, ssk] 2 times, k9; rep from *.

RND 21: *[K2tog, yo] 2 times, k1, [yo, ssk] 2 times, k4, M1, k1, M1, k4; rep from *—100 sts.

RND 23: *[K2tog, yo] 2 times, k1, [yo, ssk] 2 times, k11; rep from *.

RND 25: *[K2tog, yo] 2 times, k1, [yo, ssk] 2 times, k5, M1, k1, M1, k5; rep from *—110 sts.

RND 27: *[K2tog, yo] 2 times, k1, [yo, ssk] 2 times, k13; rep from *.

RND 29: *[K2tog, yo] 2 times, k1, [yo, ssk] 2 times, k6, M1, k1, M1, k6; rep from *—120 sts.

RND 31: *[K2tog, yo] 2 times, k1, [yo, ssk] 2 times, k15; rep from *.

RND 33: *[K2tog, yo] 2 times, k1, [yo, ssk] 2 times, k7, M1, k1, M1, k7; rep from *—130 sts.

RND 35: *[K2tog, yo] 2 times, k1, [yo, ssk] 2 times, k17; rep from *.

RND 36: Knit.

RNDS 37–60: Rep Rnds 35 and 36 twelve more times.

RND 61: Knit.

BRIM

RND 1: *P1, k1tbl, p1, k2; rep from *.

RND 2: (inc rnd) *P1, k1tbl, p1, k1, yo, k1; rep from *—156 sts.

RND 3: *P1, k1tbl, p1, k3; rep from *.

RND 4: (dec rnd) *P1, k1tbl, p1, k3, pass 3rd st on right needle over first 2 sts; rep from *—130 sts.

RNDS 5–16: Rep Rnds 1–4 three more times.

RND 17: Rep Rnd 1.

BO all sts loosely.

Finishing

Weave in loose ends. Block to measurements.

Tie an overhand knot with both ties on top of hat.

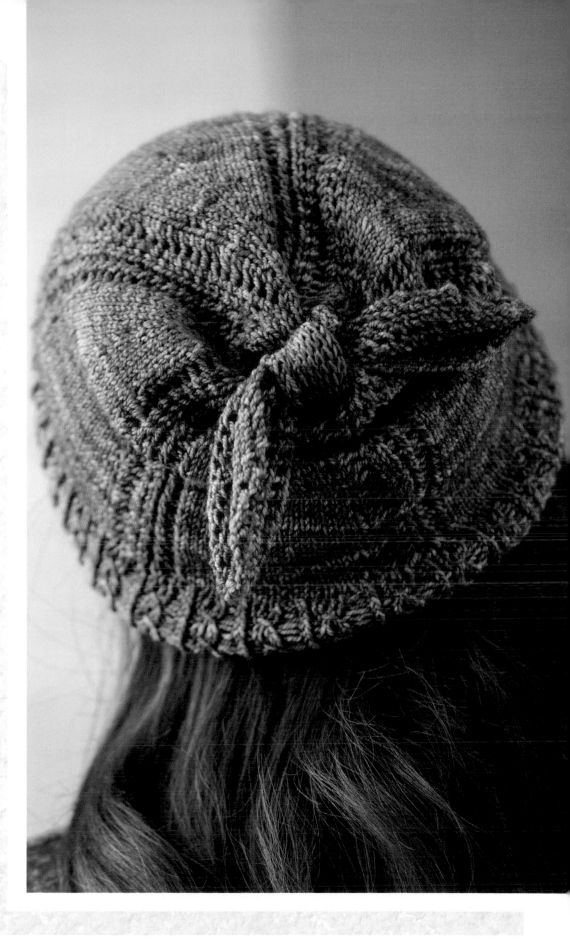

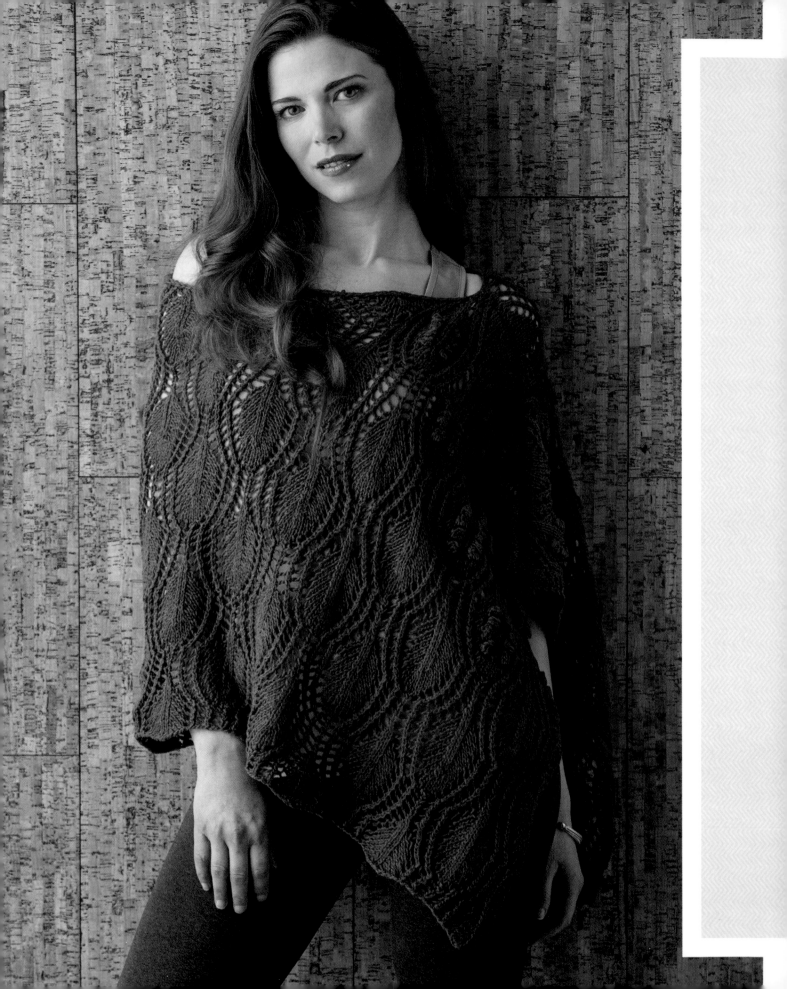

FINISHED SIZE
51" (129.5 cm) wide and
22" (56 cm) high before
seaming.

25" (63.5 cm) wide and
21¾" (55 cm) high after
seaming.

YARN
Worsted weight
(#4 Medium).

Shown here: Rowan
Creative Linen (50%
linen, 50% cotton; 219 yd
[200 m]/100 g): #635,
4 skeins.

NEEDLES
Size U.S. 9 (5.5 mm).

*Adjust needle size if
necessary to obtain the
correct gauge.*

NOTIONS
Tapestry needle;
removable markers (m).

GAUGE
19 sts and 32 rows of Main
patt = 5" (12.5 cm) wide
and 5½" (14 cm) long.

Hyacinth

This poncho is knitted flat as a simple rectangle shape. I used the hyacinth pattern all over and added bobbles on some of the repeats, because I love the texture it adds to the lacy pattern! But if you prefer to make yours with lace only, you can easily leave off the bobbles.

STITCH GUIDE

MAKE BOBBLE (MB)
Work [k1, p1] twice all in the same st—4 sts made from 1 st. Turn work, p4 with WS facing, turn work, k4, turn work, p4tog, turn work, k1 with RS facing— 4 sts dec'd to 1 st again.

SL 1 PWISE WYF
Slip 1 st purlwise with yarn in front.

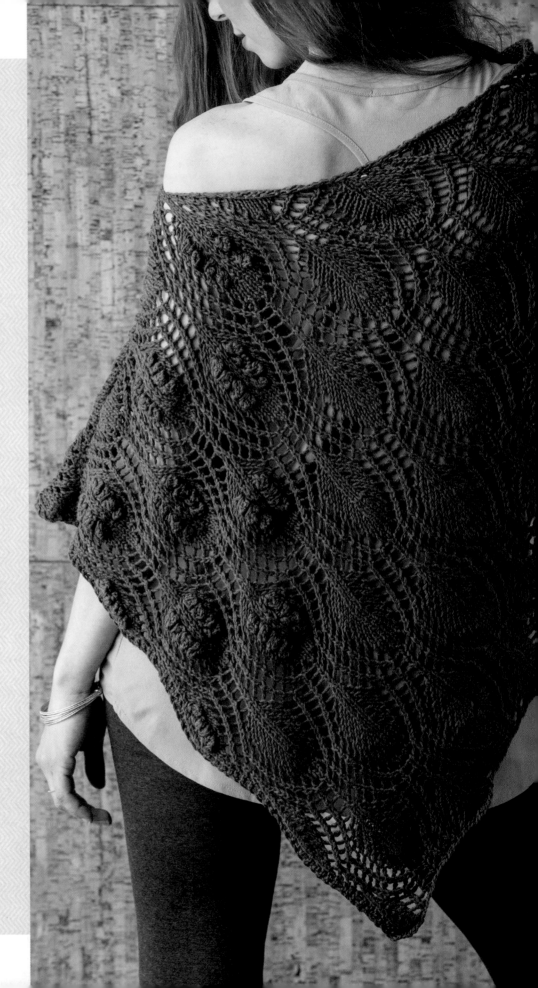

Instructions

CO 196 sts.

SET-UP ROW: Purl.

SECTION 1
Work Rows 1–32 of Main patt from chart, working the 19-st patt repeat 9 times.

Work Rows 1–32 of Main patt once more.

SECTION 2
This section uses 19-st variations on the Main patt from Section 1 to add bobbles to the piece. If you prefer not to have any bobbles, work Section 2 as in Section 1.

Establish patt from Row 1 of both Right Side and Left Side charts as follows:

ROW 1: (RS) Work first 3 sts of Right Side chart, place marker (pm), work 19-st bobble patt rep once, pm, work next 19 sts of Right Side chart, work 19-st main patt rep 6 times;

MAIN

		k on RS; p on WS			\	ssk
		p on RS; k on WS			⊻	sl 1 pwise wyf on RS
		o	yo		v	sl 1 pwise wyf on WS
		∕	k2tog			pattern repeat

19-st repeat

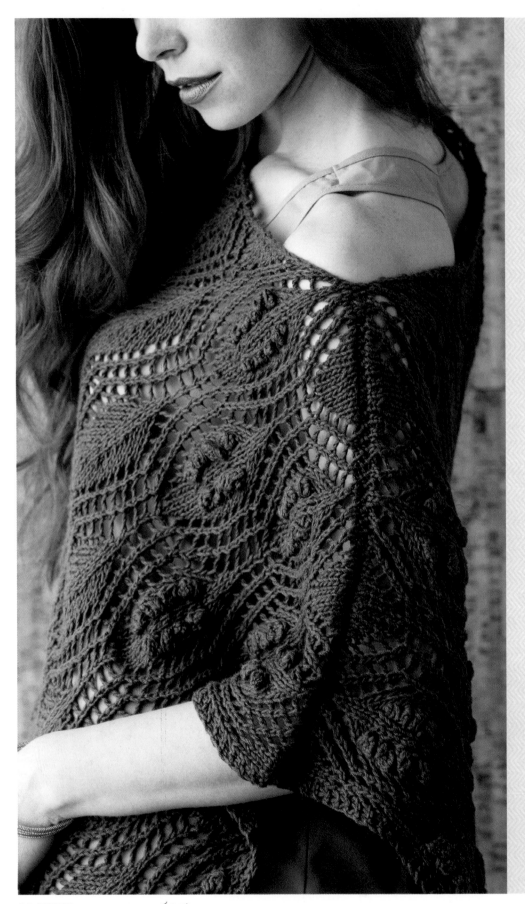

work the first 19 sts of Left Side chart, pm, work 19-st bobble patt rep 0 times, work last 22 sts of Left Side chart.

Cont as established until Rows 2–32 of Right Side and Left Side charts have been worked once.

NEXT ROW: (RS) Work first 3 sts of Right Side chart, pm, work 19-st bobble patt rep twice, pm, work next 19 sts of Right Side chart, work 19-st main patt rep 4 times; work the first 19 sts of Left Side chart, pm, work 19-st bobble patt rep once, work last 22 sts of Left Side chart.

Cont as established until Rows 2–32 of Right Side and Left Side charts have been worked once.

NEXT ROW: (RS) Loosely BO 51 sts, pm, BO 94 sts, pm, BO 51 sts.

Finishing

With RS facing and BO edge at top, fold in half to match markers on BO edge. Using mattress st (see Glossary), sew the 2 sides of the BO edge from markers to selvedges. The remaining space in the BO edge will become the neck opening.

Weave in loose ends. Block to measurements.

RIGHT SIDE

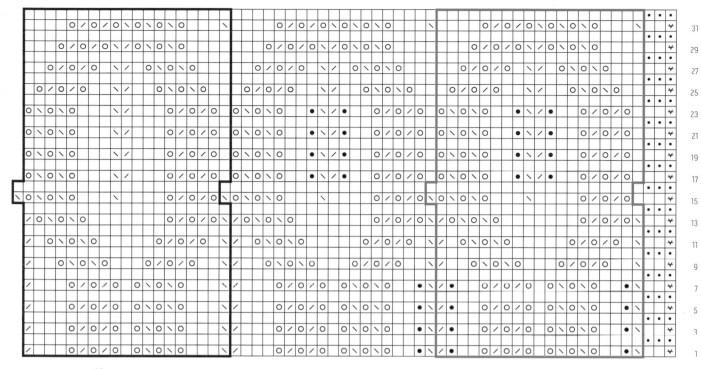

19-st repeat 19-st repeat

LEFT SIDE

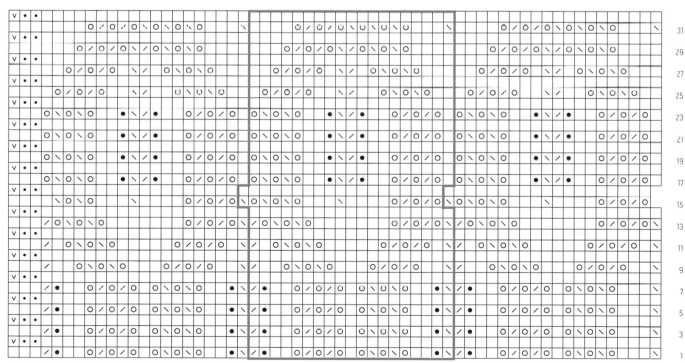

19-st repeat

	k on RS; p on WS		/	k2tog		v	sl 1 pwise wyf on WS
•	p on RS; k on WS		\	ssk			main pattern
o	yo		•	MB (make bobble— see Stitch Guide)			bobble variation

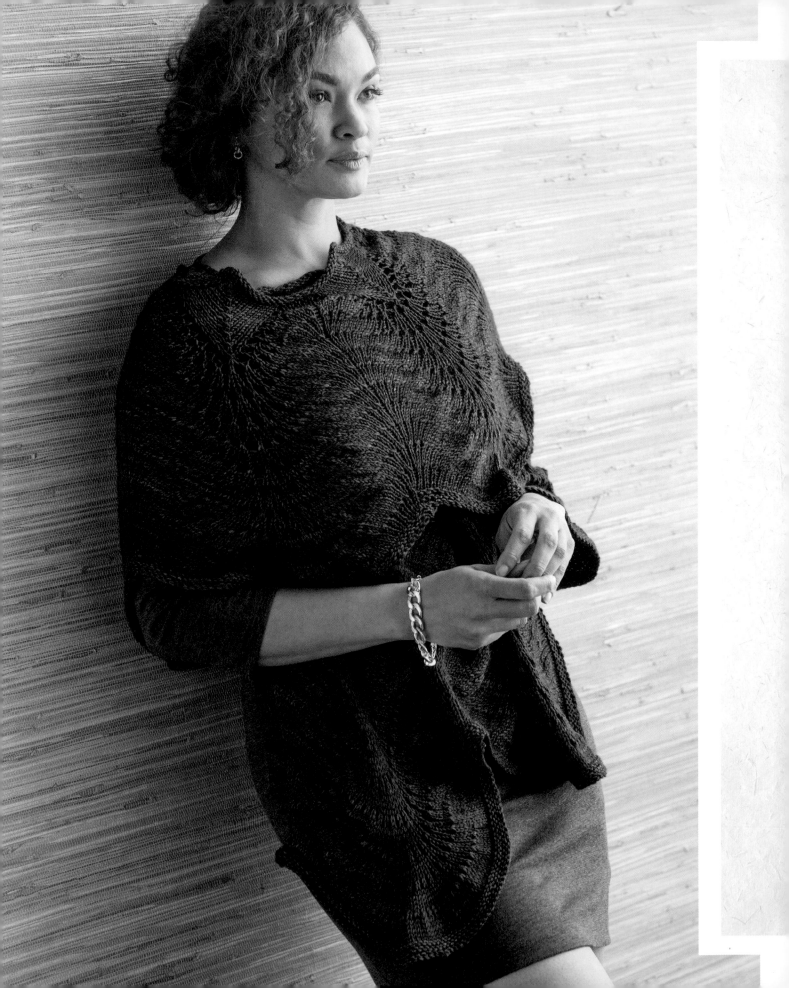

FINISHED SIZE

About 58½" (148.5 cm) wide along top edge and 100" (254 cm) wide along bottom edge.

About 14¼" (36 cm) long for shortest panel and 32" (81.5 cm) long for longest panel.

YARN

DK weight (#3 Light).

Shown here: Madelinetosh Tosh DK (100% superwash merino wool; 225 yd [206 m]/100 g): Saffron, 5 skeins.

NEEDLES

Size U.S. 9 (5.5 mm): 24" (61 cm) or longer circular (cir).

Adjust needle size if necessary to obtain the correct gauge.

NOTIONS

Markers (m); tapestry needle.

GAUGE

18 sts and 22 rows = 4" (10 cm) in St st.

31 sts and 18 rows of Rows 1–17 from Feather and Fan chart = 7" (18 cm) wide and 4¼" (11 cm) long.

Waves of Grain

At first, my plan for this project was to use short-rows to create the asymmetrical shape, but it would have been too complicated a pattern. Then I tried to use entrelac and combine different sizes of mitered squares. Finally I decided to use an arrangement of feather and fan. The resulting pattern uses a simple method that is pretty easy once you get the hang of it. The shawl is made of nine panels of feather and fan of varying lengths, which create the asymmetrical shape.

STITCH GUIDE

DOUBLE DECREASE (DD)
Slip 1 st as if to knit, k2tog, pass slipped stitch over—2 sts dec'd.

STOCKINETTE STITCH WITH SELVEDGE (St st with selvedge)
ROW 1: (RS) Sl 1, knit to end.
ROW 2: (WS) Sl 1, k1, purl to last 2 sts, k2.

Instructions

CO 211 sts.

SET-UP ROW 1: P2, place marker (pm), [p23, pm] 9 times, p2. The 10 markers divide your piece into 9 panels that will be worked identically until the short-rows section.

SET-UP ROW 2: Knit.

NECKLINE

Work Rows 1–20 from written instructions below or from Neckline chart.

ROW 1: (RS) Sl 1, k1, [k1, yo, k9, DD (see Stitch Guide), k9, yo, k1] 9 times, k2.

ROW 2 AND ALL EVEN-NUMBERED ROWS: Sl 1, k1, purl to last 2 sts, k2.

ROW 3: Sl 1, k1, [k2, yo, k8, DD, k8, yo, k2] 9 times, k2.

ROW 5: Sl 1, k1, [k3, yo, k7, DD, k7, yo, k3] 9 times, k2.

ROW 7: Sl 1, k1, [k4, yo, k6, DD, k6, yo, k4] 9 times, k2.

ROW 9: Sl 1, k1, [k4, yo, k1, yo, k5, DD, k5, yo, k1, yo, k4] 9 times, k2—229 sts (25 sts between m).

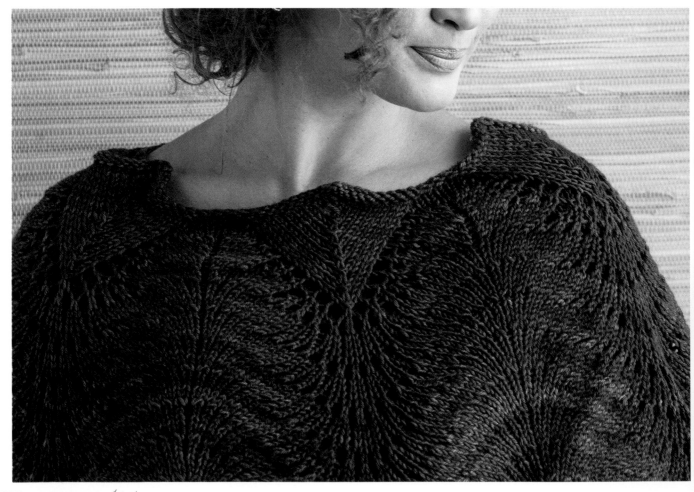

NECKLINE

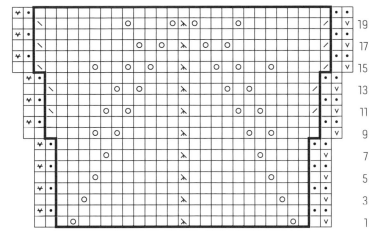

23-st repeat inc'd to 27-st repeat

☐ k on RS; p on WS	⋋ DD (see Stitch Guide)
· p on RS; k on WS	v sl 1 wyb on RS; sl 1 wyf on WS
○ yo	⊬ sl 1 wyf on RS; sl 1 wyb on WS
╱ k2tog	☐ pattern repeat
╲ ssk	

FEATHER + FAN Rows 1 to 42

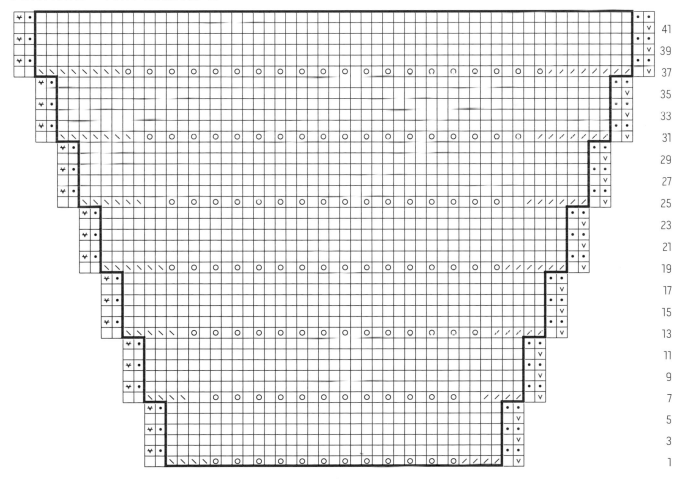

31-st repeat inc'd to 55-st repeat

ROW 11: Sl 1, k1, [k2tog, k4, yo, k1, yo, k4, DD, k4, yo, k1, yo, k4, ssk] 9 times, k2.

ROW 13: Sl 1, k1, [k2tog, k5, yo, k1, yo, k3, DD, k3, yo, k1, yo, k5, ssk] 9 times, k2.

ROW 15: Sl 1, k1, [k2tog, k4, yo, k2, yo, k1, yo, k2, DD, k2, yo, k1, yo, k2, yo, k4, ssk] 9 times, k2—247 sts (27 sts between m).

ROW 17: Sl 1, k1, [k2tog, k8, yo, k1, yo, k1, DD, k1, yo, k1, yo, k8, ssk] 9 times, k2.

ROW 19: Sl 1, k1, [k2tog, k7, yo, k3, yo, DD, yo, k3, yo, k7, ssk] 9 times, k2.

ROW 20: Rep Row 2.

FEATHER AND FAN BEGINNING SECTION

Work Rows 1–42 from written instructions below or from Feather and Fan chart (Rows 1–42).

ROW 1: (RS) Sl 1, k1, *[k2tog] 4 times, [yo, k1] 11 times, yo, [ssk] 4 times; rep from * to last 2 sts, k2—283 sts (31 sts between m).

ROWS 2–6: Work St st with selvedge (see Stitch Guide) starting with WS row.

ROW 7: Sl 1, k1, *[k2tog] 4 times, k2, [yo, k1] 12 times, k1, [ssk] 4 times; rep from * to last 2 sts, k2—319 sts (35 sts between m).

ROWS 8–12: Work St st with selvedge starting with WS row.

ROW 13: Sl 1, k1, *[k2tog] 5 times, k1, [yo, k1] 14 times, [ssk] 5 times; rep from * to last 2 sts, k2—355 sts (39 sts between m).

ROWS 14–18: Work St st with selvedge starting with WS row.

ROW 19: Sl 1, k1, *[k2tog] 6 times, [yo, k1] 15 times, yo, [ssk] 6 times; rep from * to last 2 sts, k2—391 sts (43 sts between m).

ROWS 20–24: Work St st with selvedge starting with WS row.

ROW 25: Sl 1, k1, *[k2tog] 6 times, k2, [yo, k1] 16 times, k1, [ssk] 6 times; rep from * to last 2 sts, k2—427 sts (47 sts between m).

ROWS 26–30: Work St st with selvedge starting with WS row.

ROW 31: Sl 1, k1, *[k2tog] 7 times, k1, [yo, k1] 18 times, [ssk] 7 times; rep from * to last 2 sts, k2—463 sts (51 sts between m).

ROWS 32–36: Work St st with selvedge starting with WS row.

ROW 37: Sl 1, k1, *[k2tog] 8 times, [yo, k1] 19 times, yo, [ssk] 8 times; rep from * to last 2 sts, k2—499 sts (55 sts between m).

ROWS 38–42: Work St st with selvedge starting with WS row.

FEATHER AND FAN SHORT-ROWS SECTION

With RS facing, the wrap is composed of 9 panels with Panel 1 being the rightmost panel. In this section, we will work in short-rows by working in garter stitch in the rightmost panel and working the Feather and Fan pattern in the other panels. By gradually binding off the rightmost panel, we create the asymmetrical shape.

Work Rows 43–96 from written instructions below. Note that the Feather and Fan chart for Rows 43–90 only shows the odd-numbered right-side rows but can be used when working pattern repeats between markers.

Panel 1

ROW 43: (RS) Sl 1, k1, *[k2tog] 8 times, k2, [yo, k1] 20 times, k1, [ssk] 8 times; rep from * 7 times, k55, k2—531 sts (59 sts in Panels 2 to 9).

ROW 44: Sl 1, k56, purl to last 2 sts, k2.

ROW 45: Sl 1, knit to end.

ROWS 46 AND 47: Rep Rows 44 and 45.

ROW 48: Loosely BO 54 sts, k3, purl to last 2 sts, k2—477 sts (59 sts between m).

Panel 2

ROW 49: Sl 1, k1, *[k2tog] 9 times, k1, [yo, k1] 22 times, [ssk] 9 times; rep from * 6 times, k58, ssk, turn work—504 sts (63 sts in Panels 3 to 9, 2 sts unworked).

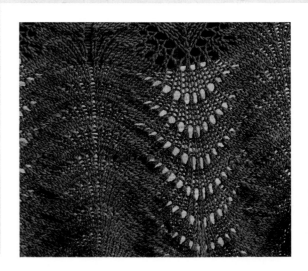

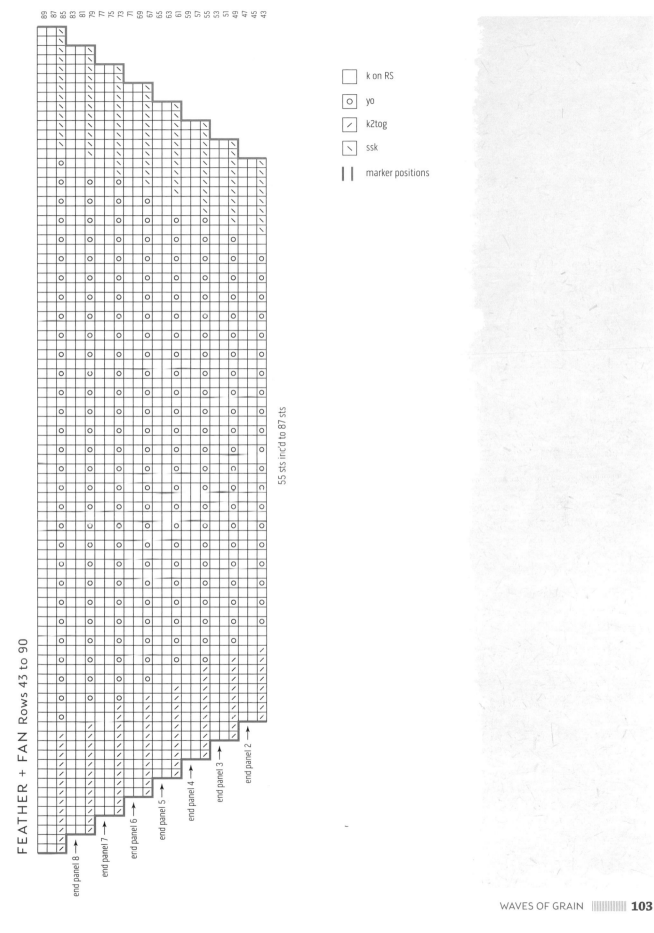

89 87 85 83 81 79 77 75 73 71 69 67 65 63 61 59 57 55 53 51 49 47 45 43

FEATHER + FAN Rows 43 to 90

55 sts inc'd to 87 sts

□ k on RS

○ yo

╱ k2tog

╲ ssk

| | marker positions

end panel 8 →
end panel 7 →
end panel 6 →
end panel 5 →
end panel 4 →
end panel 3 →
end panel 2 →

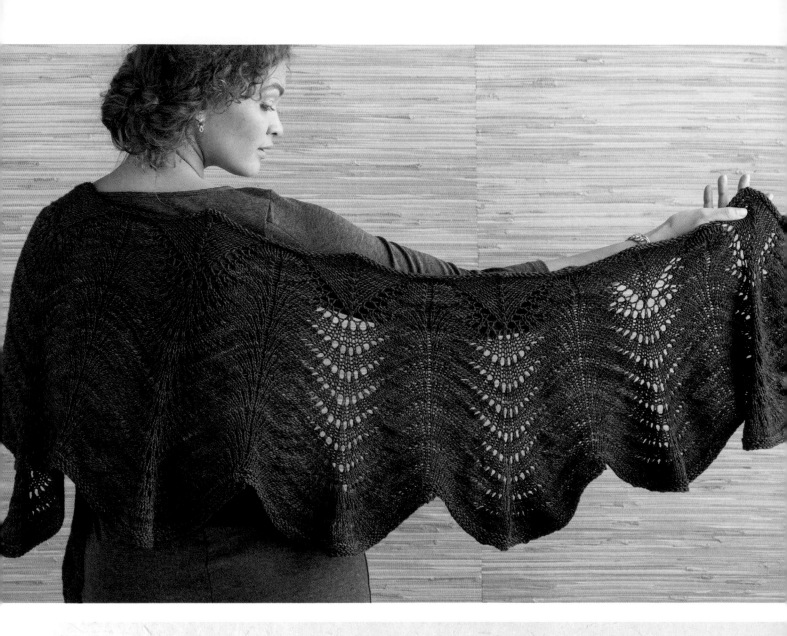

ROW 50: K59, purl to last 2 sts, k2.

ROW 51: Sl 1, knit to last 3 sts, ssk, turn work—503 sts (1 st unworked).

ROW 52: K59, purl to last 2 sts, k2.

ROW 53: Sl 1, knit to last 2 sts, ssk—502 sts.

ROW 54: Loosely BO 56 sts, k3, purl to last 2 sts, k2—446 sts (63 sts between m).

Panel 3

ROW 55: Sl 1, k1, *[k2tog] 10 times, [yo, k1] 23 times, yo, [ssk] 10 times; rep from * 5 times, k62, ssk, turn work—469 sts (67 sts in Panels 4 to 9, 2 sts unworked).

ROW 56: K63, purl to last 2 sts, k2.

ROW 57: Rep Row 51—468 sts.

ROW 58: K63, purl to last 2 sts, k2.

ROW 59: Rep Row 53—467 sts.

ROW 60: Loosely BO 60 sts, k3, purl to last 2 sts, k2—407 sts (67 sts between m).

Panel 4

ROW 61: Sl 1, k1, *[k2tog] 10 times, k2, [yo, k1] 24 times, k1, [ssk] 10 times; rep from * 4 times, k66, ssk, turn work—426 sts (71 sts in Panels 5 to 9, 2 sts unworked).

ROW 62: K67, purl to last 2 sts, k2.

ROW 63: Rep Row 51—425 sts.

ROW 64: K67, purl to last 2 sts, k2.

ROW 65: Rep Row 53—424 sts.

ROW 66: Loosely BO 64 sts, k3, purl to last 2 sts, k2—360 sts (71 sts between m).

Panel 5

ROW 67: Sl 1, k1, *[k2tog] 11 times, k1, [yo, k1] 26 times, [ssk] 11 times; rep from * 3 times, k70, ssk, turn work—375 sts (75 sts in Panels 6 to 9, 2 sts unworked).

ROW 68: K71, purl to last 2 sts, k2.

ROW 69: Rep Row 51—374 sts.

ROW 70: K71, purl to last 2 sts, k2.

ROW 71: Rep Row 53—373 sts.

ROW 72: Loosely BO 68 sts, k3, purl to last 2 sts, k2—305 sts (75 sts between m).

Panel 6

ROW 73: Sl 1, k1, *[k2tog] 12 times, [yo, k1] 27 times, yo, [ssk] 12 times; rep from * twice, k74, ssk, turn work—316 sts (79 sts in Panels 7 to 9, 2 sts unworked).

ROW 74: K75, purl to last 2 sts, k2.

ROW 75: Rep Row 51—315 sts.

ROW 76: K75, purl to last 2 sts, k2.

ROW 77: Rep Row 53—314 sts.

ROW 78: Loosely BO 72 sts, k3, purl to last 2 sts, k2—252 sts (79 sts between m).

Panel 7

ROW 79: Sl 1, k1, *[k2tog] 12 times, k2, [yo, k1] 28 times, k1, [ssk] 12 times; rep from * once, k78, ssk, turn work—249 sts (83 sts in Panels 8 and 9, 2 sts unworked).

ROW 80: K79, purl to last 2 sts, k2.

ROW 81: Rep Row 51—248 sts.

ROW 82: K79, purl to last 2 sts, k2.

ROW 83: Rep Row 53—247 sts.

ROW 84: Loosely BO 76 sts, k3, purl to last 2 sts, k2—171 sts (83 sts between m).

Panel 8

ROW 85: Sl 1, k1, [k2tog] 13 times, k1, [yo, k1] 30 times, [ssk] 13 times, k82, ssk, turn work— 174 sts (2 sts unworked).

ROW 86: K83, purl to last 2 sts, k2.

ROW 87: Rep Row 51—173 sts.

ROW 88: K83, purl to last 2 sts, k2.

ROW 89: Rep Row 53—172 sts.

ROW 90: Loosely BO 80 sts, k3, purl to last 2 sts, k2—92 sts.

Panel 9

ROW 91: Sl 1, k87, ssk, turn— 91 sts (2 sts unworked).

ROW 92: Knit.

ROW 93: Rep Row 51—90 sts.

ROW 94: Knit.

ROW 95: Rep Row 53—89 sts.

ROW 96: Loosely BO all sts.

Finishing

Block to measurements (this is a very important step). Weave in loose ends.

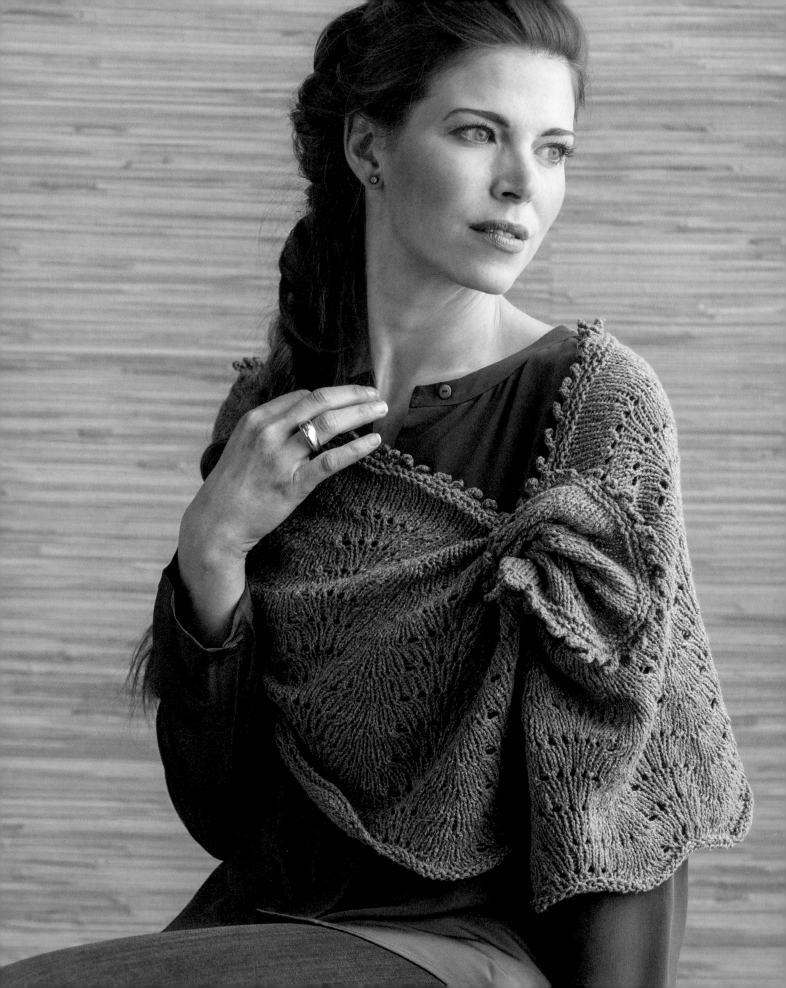

FINISHED SIZE

46 (53)" (117 [134.5] cm) circumference and 14½ (16½)" (37 [42] cm) long.

Capelet shown measures 46" (117 cm).

YARN

DK weight (#3 Light).

Shown here: Elsebeth Lavold Silky Wool (45% wool, 35% silk, 20% nylon; 192 yd [176 m]/50 g): #60 Granite (MC), 3 (4) skeins; #98 Antique Rose (CC), 1 (1) skein.

NEEDLES

Size U.S. 7 (4.5 mm): 24" (61 cm) or longer circular (cir).

Adjust needle size if necessary to obtain the correct gauge.

NOTIONS

Markers (m); tapestry needle.

GAUGE

19 sts and 31 rnds = 4" (10 cm) in Feather and Fan patt after blocking.

18 sts and 30 rnds = 4" (10 cm) in St st.

Lily of the Valley

This capelet is worked in the round in a feather and fan pattern that creates a wavy bottom edge. A keyhole is created near the neckline, and pulling fabric from both sides through this keyhole allows you to adjust the size of the neck opening. In addition, the fabric pulled through looks like a cute bow accenting the neckline.

STITCH GUIDE

FEATHER AND FAN PATTERN

(multiple of 17 sts)

RNDS 1 AND 2: Knit.

RND 3: *[K2tog] 3 times, [yo, k1] 5 times, yo, [ssk] 3 times; rep from *.

RNDS 4–8: Knit.

Rep Rnds 1–8 for patt.

7-ST ONE-ROW BUTTONHOLE (7-st BH)

Bring the yarn to the front of the work, slip the next stitch purlwise, then return the yarn to the back. *Slip the next stitch, pass the 2nd stitch over the slipped stitch, and drop it off the needle. Repeat from * 5 more times. Slip the last stitch on the right needle to the left needle and turn the work around. Bring the working yarn to the back, using the cable cast-on method (see Glossary), CO 7 sts. Turn the work around. With the yarn in back, slip the first stitch and pass the extra cast-on stitch over it and off the needle to complete the buttonhole.

5 (6, 7)-ST PICOT BIND-OFF

(5 [6, 7]-st PBO)

Slip last stitch on right needle to left needle. Using the cable cast-on method, CO 3 (4, 5) sts, then using the standard bind-off method (see Glossary), BO 5 (6, 7) sts.

MAIN SECTION

With MC, CO 221 [255] sts. Place marker (pm) and join for working in the rnd, being careful not to twist sts.

RNDS 1 AND 2: Purl.

RNDS 3–98 [3–114]: Work Rnds 1–8 of Feather and Fan patt (see Stitch Guide) a total of 12 [14] times.

NOTE: For a longer capelet, work more repeats of the Feather and Fan patt. Each patt repeat will increase the length by about 1" (2.5 cm). Plan to purchase extra yarn if making a bigger capelet.

KEYHOLE

RNDS 1–7: Knit.

RND 8: Purl.

RND 9: K1, work 7-st BH, knit to end.

RND 10: Purl.

EDGING

Change to CC.

RND 1: Knit

RND 2: *K6, k2tog, k7, k2tog; rep from * to end—195 [225] sts.

RND 3: K2tog, *[7-st PBO (see Stitch Guide), 5-st PBO, 7-st PBO, 6-st PBO]; rep from * 27 [31] times until all sts have been bound off.

Finishing

Weave in loose ends. Block to measurements.

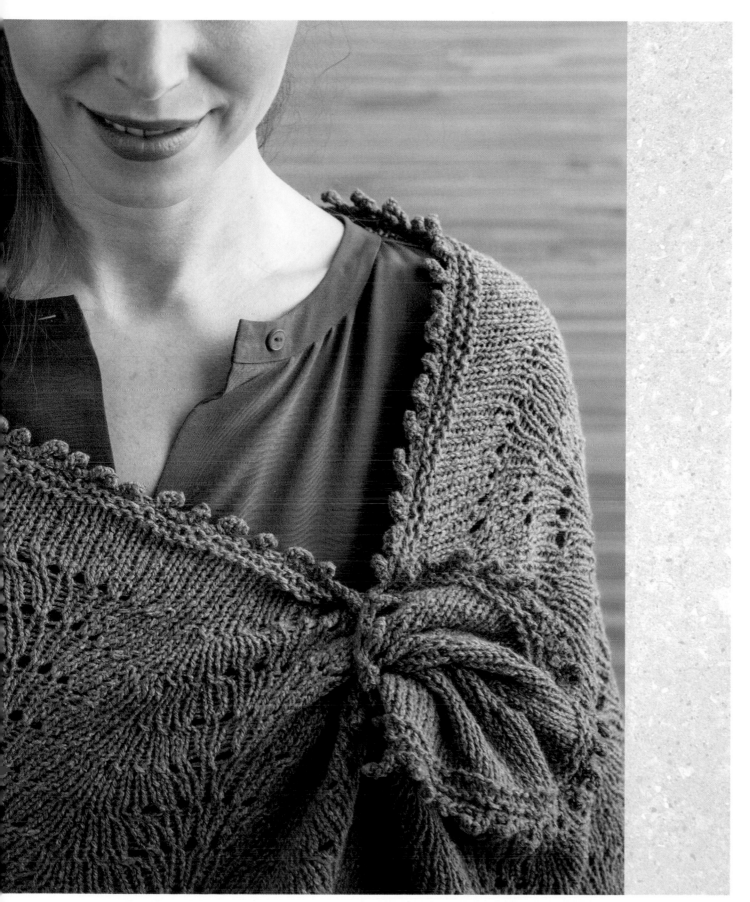

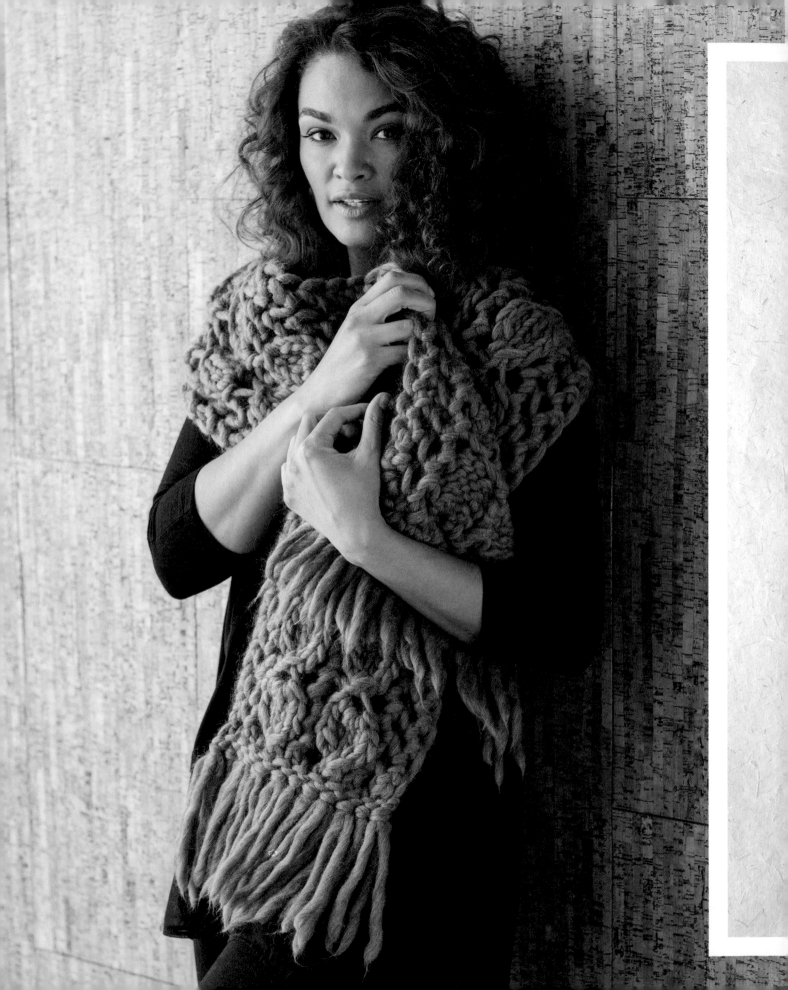

FINISHED SIZE

10" (25.5 cm) wide and 55" (139.5 cm) long without fringe (fringe adds about 12" [30.5 cm] to length).

YARN

Bulky weight (#6 Super Bulky).

Shown here: Cascade Magnum (100% wool, 123 yd [112 m]/250 g): #8013 Walnut Heather, 2 skeins.

NEEDLES

Size U.S. 19 (15 mm).

Adjust needle size if necessary to obtain the correct gauge.

NOTIONS

Tapestry needle; size P (15mm) crochet hook for fringe.

GAUGE

12 sts and 6 rows of Main patt = 10" (25.5 cm) wide and 3" (7.5 cm) long.

Winter Rose

I love this style of yarn—a single ply, super bulky weight in a color that I can still imagine on the sheep. But super bulky is a challenging weight to use when designing a wearable and fashionable piece. I experimented with many combinations of lace and textured patterns before ending up with this pattern, which made me very happy.

STITCH GUIDE

5-IN-1 INC
Work (k1, p1, k1, p1, k1) all in the same st.

Work a yarnover at the beginning of a row by bringing the yarn over the top of the right needle before working p2tog.

MAIN PATTERN
(worked over 12 sts)

ROW 1: (RS) Yo, p2tog, [yo, p2tog, 5-in-1 inc (see Stitch Guide)] 2 times, [yo, p2tog] 2 times—20 sts.

ROW 2: Yo, p2tog, [yo, p2tog, p5] 2 times, [yo, p2tog] 2 times.

ROW 3: Yo, p2tog, [yo, p2tog, k5] 2 times, [yo, p2tog] 2 times.

ROW 4: Rep Row 2.

ROW 5: Yo, p2tog, [yo, p2tog, ssk, k1, k2tog] 2 times, [yo, p2tog] 2 times—16 sts.

ROW 6: Yo, p2tog, [yo, p2tog, p3tog] 2 times, [yo, p2tog] 2 times—12 sts.

Rep Rows 1–6 for patt.

Note that the stitch count for the main patt does not remain constant throughout.

Instructions
CO 12 sts loosely.

ROW 1: Knit.

ROWS 2–109: Work Rows 1–6 of Main patt (from Stitch Guide or chart) 18 times.

ROW 110: Knit.

Loosely BO all sts.

NOTE: To lengthen the scarf, work the Main patt more times. Each repeat will add about 3" (7.5 cm) of length. Keep in mind that yarn requirements will be affected.

Finishing

FRINGE
Attach 12 tassels (instructions below) evenly spaced across CO edge. Rep for BO edge.

TASSEL
(make 24)

Cut 2 strands of yarn about 13" (33 cm) long. Hold 2 strands tog and fold in half. With RS facing, insert crochet hook from WS to RS into stitch above the CO edge of scarf and pull folded ends of strands through to form loop. Thread ends of strands through loop and pull ends down to close loop tightly.

MAIN PATTERN

12-st repeat (increasing to 20 sts)

□ k on RS; p on WS	⟍ p2tog	
○ yo	✕ p3tog	
╱ k2tog	⚓ 5-in-1 inc (see Stitch Guide)	
╲ ssk	▨ no stitch	
	□ pattern repeat	

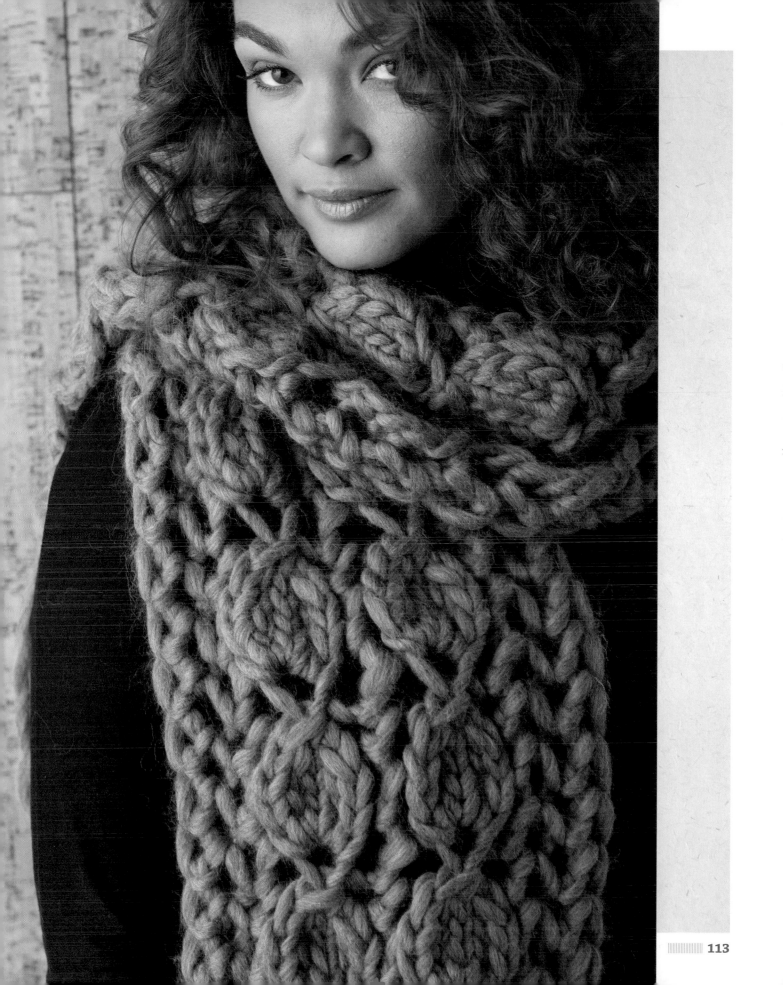

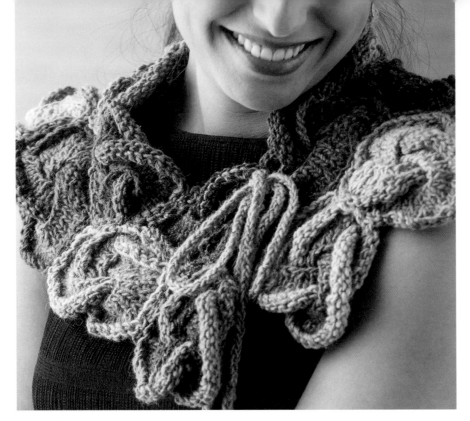

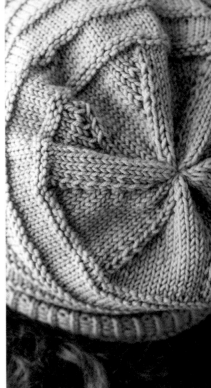

Abbreviations

BEG(S)	begin(s); beginning	**m**	marker(s)	**st(s)**	stitch(es)
BO	bind off	**mm**	millimeter(s)	**St st**	stockinette stitch
cir	circular	**M1**	make one (increase)	**tbl**	through back loop
cm	centimeter(s)	**p**	purl	**tog**	together
cn	cable needle	**p1f&b**	purl into front and back of same stitch	**WS**	wrong side
CO	cast on	**p2tog**	purl 2 stitches together	**wyb**	with yarn in back
cont	continue(s); continuing	**p3tog**	purl 3 stitches together	**wyf**	with yarn in front
dec(s)('d)	decrease(s); decreasing; decreased	**patt(s)**	pattern(s)	**yd**	yard(s)
dpn	double-pointed needles	**pm**	place marker	**yo**	yarnover
foll(s)	follow(s); following	**psso**	pass slipped stitch over	*****	repeat starting point
g	gram(s)	**pwise**	purlwise; as if to purl	******	repeat all instructions between asterisks
inc(s)('d)	increase(s); increasing; increase(d)	**rem**	remain(s); remaining	**()**	alternate measurements and/or instructions
k	knit	**rep**	repeat(s); repeating		
k1f&b	knit into the front and back of same stitch	**rnd(s)**	round(s)	**[]**	work instructions as a group a specified number of times
k2tog	knit 2 stitches together	**RS**	right side		
k3tog	knit 3 stitches together	**sl**	slip		
kwise	knitwise, as if to knit	**sl st**	slip st (slip stitch purlwise unless otherwise indicated)		
		ssk	slip, slip, knit (decrease)		

Glossary

CAST-ONS

↓ BACKWARD-LOOP CAST-ON

*Loop working yarn and place it on needle backward so that it doesn't unwind. Repeat from *.

↓ CABLE CAST-ON

If there are no stitches on the needle, make a slipknot of working yarn and place it on the needle, then use the knitted method to cast on one more stitch—two stitches on needle. Hold needle with working yarn in your left hand with the wrong side of the work facing you. *Insert right needle between the first two stitches on left needle (**Fig. 1**), wrap yarn around needle as if to knit, draw yarn through (**Fig. 2**), and place new loop on left needle (**Fig. 3**) to form a new stitch. Repeat from * for the desired number of stitches, always working between the first two stitches on the left needle.

↓ CROCHET CHAIN PROVISIONAL CAST-ON

With waste yarn and crochet hook, make a loose crochet chain (see page 123) about four stitches more than you need to cast on. With knitting needle, working yarn, and beginning two stitches from end of chain, pick up and knit one stitch through the back loop of each crochet chain (**Fig. 1**) for desired number of stitches. When you're ready to work in the opposite direction, pull out the crochet chain to expose live stitches (**Fig. 2**).

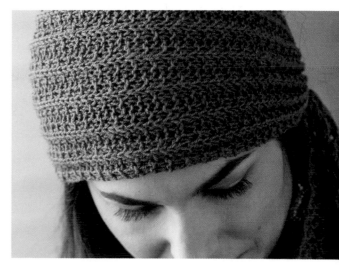

→ INVISIBLE PROVISIONAL CAST-ON

Make a loose slipknot of working yarn and place it on the right needle. Hold a length of contrasting waste yarn next to the slipknot and around your left thumb; hold working yarn over your left index finger. *Bring the right needle forward under waste yarn, over working yarn, grab a loop of working yarn (**Fig. 1**), then bring the needle back behind the working yarn and grab a second loop (**Fig. 2**). Repeat from * for the desired number of stitches. When you're ready to work in the opposite direction, place the exposed loops on a knitting needle as you pull out the waste yarn.

→ KNITTED CAST-ON

Make a slipknot of working yarn and place it on the left needle if there are no stitches already there. *Use the right needle to knit the first stitch (or slipknot) on left needle (**Fig. 1**) and place new loop onto left needle to form a new stitch (**Fig. 2**). Repeat from * for the desired number of stitches, always working into the last stitch made.

→ LONG-TAIL (CONTINENTAL) CAST-ON

Leaving a long tail (about ½" [1.3 cm] for each stitch to be cast on), make a slipknot and place on right needle. Place thumb and index finger of your left hand between the yarn ends so that working yarn is around your index finger and tail end is around your thumb and secure the yarn ends with your other fingers. Hold your palm upward, making a V of yarn (**Fig. 1**). *Bring needle up through loop on thumb (**Fig. 2**), catch first strand around index finger, and go back down through loop on thumb (**Fig. 3**). Drop loop off thumb and, placing thumb back in V configuration, tighten resulting stitch on needle (**Fig. 4**). Repeat from * for the desired number of stitches.

BIND-OFFS

↓ STANDARD BIND-OFF

Knit the first stitch, *knit the next stitch (two stitches on right needle), insert left needle tip into first stitch on right needle (**Fig. 1**) and lift this stitch up and over the second stitch (**Fig. 2**) and off the needle (**Fig. 3**). Repeat from * for the desired number of stitches.

BLOCKING

STEAM BLOCKING

Pin the pieces to be blocked to a blocking surface. Hold an iron set on the steam setting ½" (1.3 cm) above the knitted surface and direct the steam over the entire surface (except ribbing). You can get similar results by placing wet cheesecloth on top of the knitted surface and touching it lightly with a dry iron. Lift and set down the iron gently; do not use a pushing motion.

INCREASES

BAR INCREASE

This type of increase forms a small bar similar to a purl stitch at the left-hand side of the increased stitch. Depending on the yarn and stitch pattern, this bar may or may not be noticeable.

↓ Knitwise (K1F&B)

Knit into a stitch but leave the stitch on the left needle (**Fig. 1**), then knit through the back loop of the same stitch (**Fig. 2**) and slip the original stitch off the needle (**Fig. 3**).

Purlwise (P1F&B)

You can work this increase purlwise by purling into the front and back of the same stitch.

RAISED MAKE-ONE INCREASE (M1)

This type of increase is characterized by the tiny twisted stitch that forms at the base of the increase. It can slant to the right or the left, and you can separate the increases by the desired number of stitches to form a prominent ridge.

→ Right Slant (MIR)

Use the left needle tip to lift the strand between the needle tips from back to front (**Fig. 1**), then knit the lifted loop through the front to twist it (**Fig. 2**).

[1]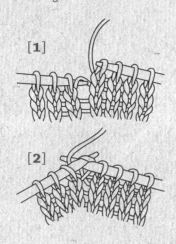

[2]

→ Left Slant (MIL)

Use the left needle tip to lift the strand between the needle tips from front to back (**Fig. 1**), then knit the lifted loop through the back to twist it (**Fig. 2**).

You can work these increases purlwise (MIP) by purling the lifted strand instead of knitting it.

[1]

[2]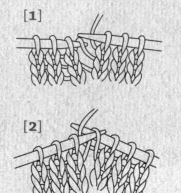

YARNOVER INCREASE

This type of increase, formed by simply wrapping the yarn around the right needle tip, forms a decorative hole. The way that the yarn is wrapped depends upon whether it is preceded or followed by a knit or purl stitch.

→ Between Two Knit Stitches

Wrap the yarn from front to back over the top of the right needle (**Fig. 1**).

[1]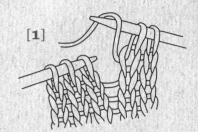

→ After a Knit Stitch and Before a Purl Stitch

Bring the yarn to the front under the right needle, around the top, then under the needle and to the front again (**Fig. 2**).

[2]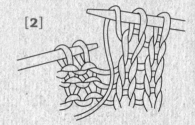

→ Between Two Purl Stitches

Bring the yarn from front to back over the top of the right needle, then around the bottom and to the front again (**Fig. 3**).

[3]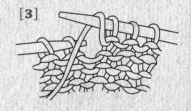

→ After a Purl Stitch and Before a Knit Stitch

Bring the yarn from front to back over the top of the right needle (**Fig. 4**).

[4]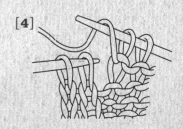

DECREASES

↓ KNIT 2 TOGETHER (K2TOG)

This type of decrease slants to the right. Knit two stitches together as if they were a single stitch.

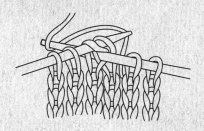

↓ SLIP, SLIP, KNIT (SSK)

This type of decrease slants to the left. Slip two stitches individually knitwise (**Fig. 1**), insert left needle tip into the front of these two slipped stitches, and use the right needle to knit them together through their back loops (**Fig. 2**).

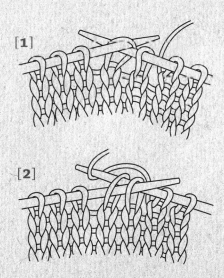

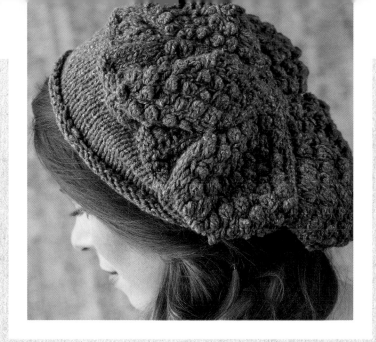

SEAMS

↓ MATTRESS STITCH

Place the pieces to be seamed on a table, right sides facing up. Begin at the lower edge and work upward.

Insert threaded needle under one bar between the two edge stitches on one piece, then under the corresponding bar plus the bar above it on the other piece (**Fig. 1**). *Pick up the next two bars on the first piece (**Fig. 2**), then the next two bars on the other (**Fig. 3**). Repeat from *, ending by picking up the last bar or pair of bars on the first piece.

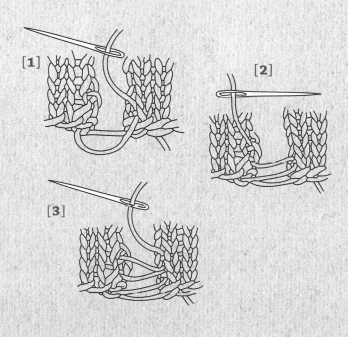

BUTTONHOLES

↓ FOUR-STITCH ONE-ROW BUTTONHOLE

Bring the yarn to the front of the work, slip the next stitch purlwise, then return the yarn to the back. *Slip the next stitch, pass the second stitch over the slipped stitch and drop it off the needle. Repeat from * once more (**Fig. 1**). Slip the last stitch on the right needle to the left needle and turn the work around. Bring the working yarn to the back, [insert the right needle between the first and second stitches on the left needle; (**Fig. 2**), draw up a loop and place it on the left needle] four times. Turn the work around. With the yarn in back, slip the first stitch and pass the extra cast-on stitch over it and off the needle to complete the buttonhole.

[1]

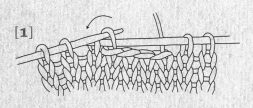

[2]

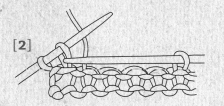

GRAFTING

→ KITCHENER STITCH

Arrange stitches on two needles so that there is the same number of stitches on each needle. Hold the needles parallel to each other with wrong sides of the knitting together. Allowing about ½" (1.3 cm) per stitch to be grafted, thread matching yarn on a tapestry needle. Work from right to left as follows:

1. Bring tapestry needle through the first stitch on the front needle as if to purl and leave the stitch on the needle (**Fig. 1**).

2. Bring tapestry needle through the first stitch on the back needle as if to knit and leave that stitch on the needle (**Fig. 2**).

3. Bring tapestry needle through the first front stitch as if to knit and slip this stitch off the needle, then bring tapestry needle through the next front stitch as if to purl and leave this stitch on the needle (**Fig. 3**).

4. Bring tapestry needle through the first back stitch as if to purl and slip this stitch off the needle, then bring tapestry needle through the next back stitch as if to knit and leave this stitch on the needle (**Fig. 4**).

Repeat Steps 3 and 4 until one stitch remains on each needle, adjusting the tension to match the rest of the knitting as you go. To finish, bring tapestry needle through the front stitch as if to knit and slip this stitch off the needle, then bring tapestry needle through the back stitch as if to purl and slip this stitch off the needle.

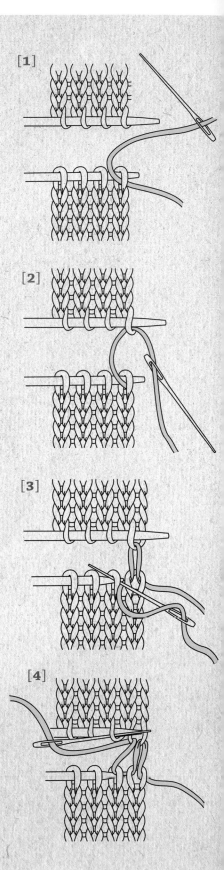

[1]

[2]

[3]

[4]

PICK UP + KNIT

↓ ALONG CAST-ON OR BIND-OFF EDGE

With right side facing and working from right to left, insert the tip of the needle into the center of the stitch below the bind-off or cast-on edge (**Fig. 1**), wrap yarn around needle, and pull through a loop (**Fig. 2**). Pick up one stitch for every existing stitch.

[1]

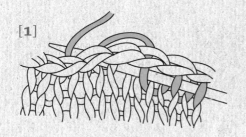

[2]

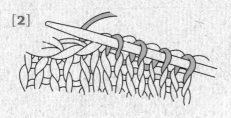

↓ ALONG SELVEDGE OR SHAPED EDGE

With right side facing and working from right to left, insert tip of needle between last and second-to-last stitches, wrap yarn around needle, and pull through a loop. Pick up and knit about three stitches for every four rows, adjusting as necessary so that picked-up edge lies flat.

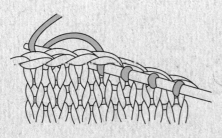

→ PICK UP AND PURL

With WS facing and working from right to left, insert right needle under selvedge stitch from farside to nearside, wrap yarn as to purl (**Fig. 1**), and pull loop through (**Fig. 2**).

[1]

[2]

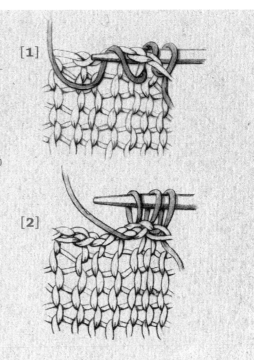

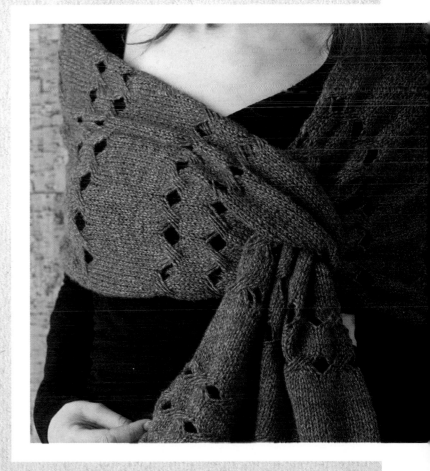

SHORT-ROWS

→ KNIT SIDE

Work to turning point, slip next stitch purlwise (**Fig. 1**), bring the yarn to the front, then slip the same stitch back to the left needle (**Fig. 2**), turn the work around and bring the yarn in position for the next stitch—one stitch has been wrapped, and the yarn is correctly positioned to work the next stitch. When you come to a wrapped stitch on a subsequent row, hide the wrap by working it together with the wrapped stitch as follows: Insert right needle tip under the wrap (from the front if wrapped stitch is a knit stitch; from the back if wrapped stitch is a purl stitch; **Fig. 3**), then into the stitch on the needle, and work the stitch and its wrap together as a single stitch.

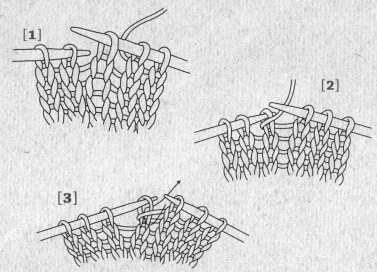

← PURL SIDE

Work to the turning point, slip the next stitch purlwise to the right needle, bring the yarn to the back of the work (**Fig. 1**), return the slipped stitch to the left needle, bring the yarn to the front between the needles (**Fig. 2**), and turn the work so that the knit side is facing—one stitch has been wrapped, and the yarn is correctly positioned to knit the next stitch. To hide the wrap on a subsequent purl row, work to the wrapped stitch, use the tip of the right needle to pick up the wrap from the back, place it on the left needle (**Fig. 3**), then purl it together with the wrapped stitch.

→ I-CORD

Using two double-pointed needles, cast on the desired number of stitches (usually three to five). *Without turning the needle, slide stitches to other end of needle, pull the yarn around the back, and knit the stitches as usual. Repeat from * for desired length.

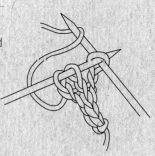

TASSELS

↓ Cut a piece of cardboard 4" (10 cm) wide by the desired length of the tassel plus 1" (2.5 cm). Wrap yarn to desired thickness around cardboard. Cut a short length of yarn and tie tightly around one end of wrapped yarn (**Fig. 1**). Cut yarn loops at other end. Cut another piece of yarn and wrap tightly around loops a short distance below top knot to form tassel neck. Knot securely, thread ends onto tapestry needle, and pull to center of tassel (**Fig. 2**). Trim ends.

CROCHET CHAIN (CH)

↓ Make a slipknot and place it on crochet hook if there isn't a loop already on the hook. *Yarn over hook and draw through loop on hook. Repeat from * for the desired number of stitches. To fasten off, cut yarn and draw end through last loop formed.

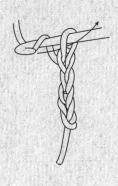

[1]

[2]

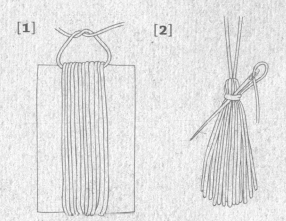

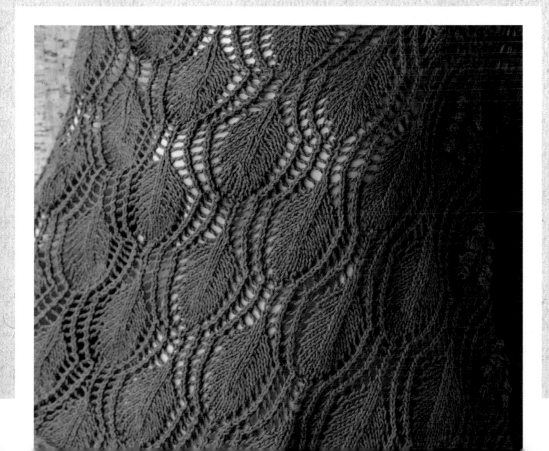

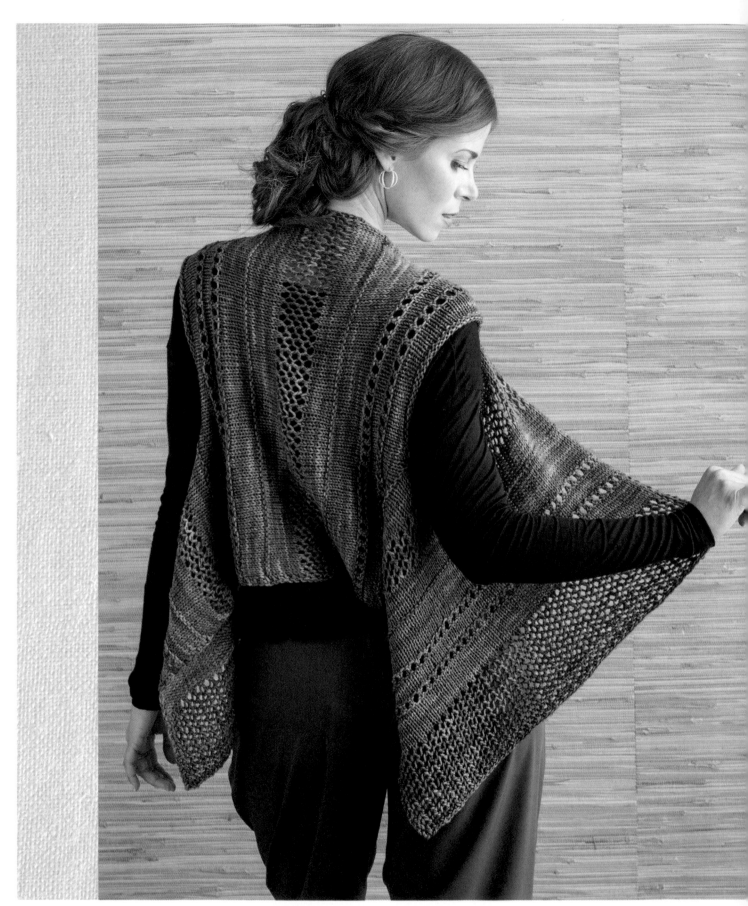

Sources for Yarns

Blue Sky Alpacas
PO Box 88
Cedar, MN 55011
blueskyalpacas.com

Brown Sheep Company
100662 County Rd. 16
Mitchell, NE 69357
brownsheep.com

Cascade Yarns
PO Box 58168
1224 Andover Park E.
Tukwila, WA 98188
cascadeyarns.com

Elsebeth Lavold
ingenkonst.se/yarn.htm

HiKoo CoBaSi
Distributed by Skacel
skacelknitting.com

Madelinetosh
7515 Benbrook Pkwy.
Benbrook, TX 76126
madelinetosh.com

Malabrigo Yarn
malabrigoyarn.com

Misti Alpaca
PO Box 2532
Glen Ellyn, IL 60138
mistialpaca.com

Westminster Fibers/Rowan
165 Ledge St.
Nashua, NH 03060
westminsterfibers.com

Schoppel Wolle
Distributed by Skacel
skacelknitting.com

Zitron
Distributed by Skacel
skacelknitting.com

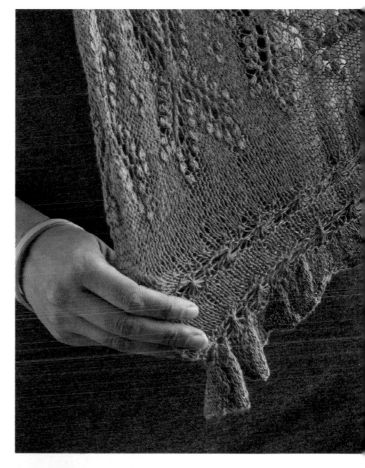

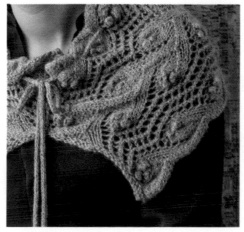

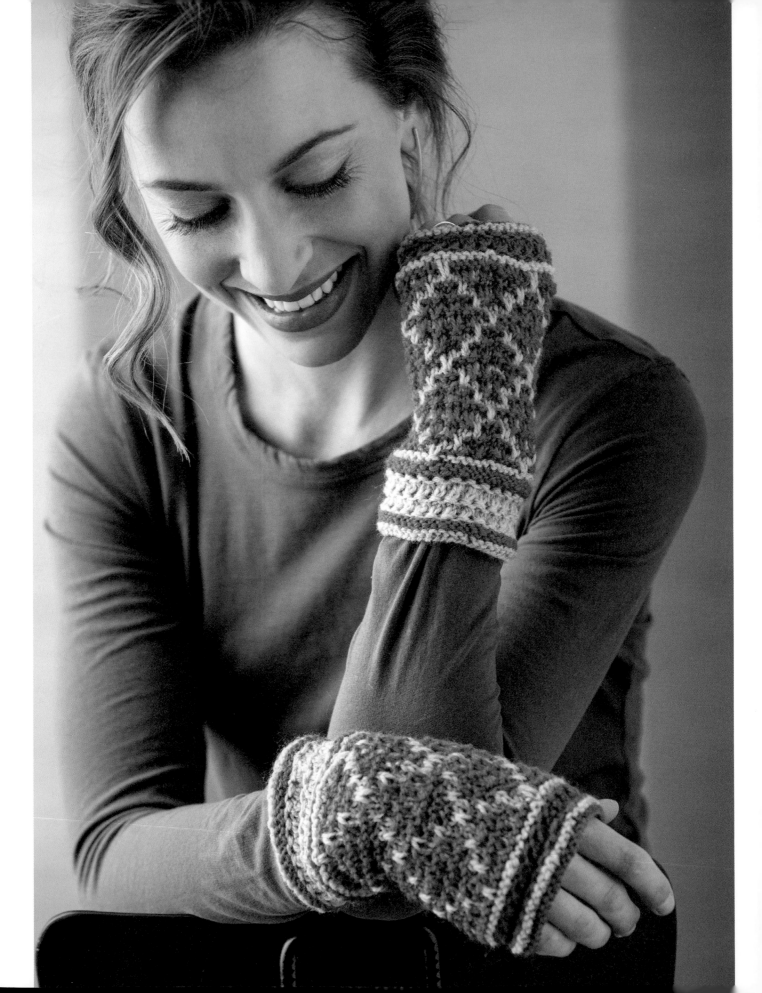

Index